THE LITERATURE OF PHOTOGRAPHY

THE LITERATURE OF PHOTOGRAPHY

Advisory Editors:

PETER C. BUNNELL
PRINCETON UNIVERSITY

ROBERT A. SOBIESZEK
INTERNATIONAL MUSEUM OF PHOTOGRAPHY
AT GEORGE EASTMAN HOUSE

VICTORIAN SNAPSHOTS

by
Paul Martin

ARNO PRESS

A NEW YORK TIMES COMPANY

NEW YORK ★ 1973

Reprint Edition 1973 by Arno Press Inc.

Reprinted by permission of
 The Hamlyn Publishing Group Ltd.

The Literature of Photography
ISBN for complete set: 0-405-04889-0
See last pages of this volume for titles.

Manufactured in the United States of America

——————◆——————

Library of Congress Cataloging in Publication Data

Martin, Paul.
 Victorian snapshots.

 (The Literature of photography)
 Reprint of the 1939 ed.
 1. Photography--History. 2. England--Social
life and customs--Illustrations. 3. England--
Social life and customs. I. Title. II. Series.
TR15.M3 1973 770'.9 72-9219
ISBN 0-405-04926-9

VICTORIAN SNAPSHOTS

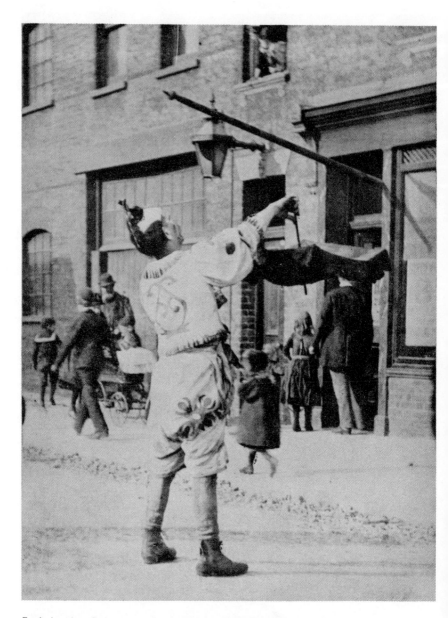

Jack-in-the-Green. A snapshot by Paul Martin in 1893 of a now forgotten London custom. On May 1st the sweeps would dress up and perform clownish antics to collect coppers, nominally for some charitable purpose. The barber's pole over the shop in Kennington still remains. (See p. 12 of illustrations.)

[*Frontispiece.*

VICTORIAN SNAPSHOTS

by
Paul Martin

With an Introduction by
Charles Harvard

Illustrated from Contemporary Photographs

LONDON
COUNTRY LIFE LIMITED
NEW YORK: CHARLES SCRIBNER'S SONS

First printed, 1939

Printed in Great Britain by
Billing and Sons Ltd., Guildford and Esher

CONTENTS

v

LIST OF ILLUSTRATIONS

INTRODUCTION

A CENTURY ago the world's mind came to be fitted with a new pictorial lining. Until the third decade of the nineteenth century the memory was fed from the real world of people and things and supported by the flat world of pictures and prints. It must have been a very colourful affair which allowed the imagination to make its way unhindered and encouraged poetical imagery to suggest an inexhaustible world of fantasy.

Then came photography. And, ever since, we have come to think more and more in terms of drab, monochrome images. An accurate and uncompromising supply of photographic knowledge is continually poured into our minds. We are fed on photographs daily until we die. They meet us on hoardings, in shops, in newspapers, in books, in our work and in many of our amusements. Behind the scenes of everyday life they have spread in their applications until there is scarcely a department of science and industry that does not employ them. Photography has not only helped the modern eclipse of time and space, but brought about a revolution in thinking and (for good or evil) transported the world to our doorstep.

Like so many inventions, photography came about through the marriage of two phenomena which had already been known for many years, but which had not yet occurred and coalesced simultaneously in the same mind. The *camera obscura* started its modern history with Leonardo da Vinci,* and by the end of the eighteenth century had become a recognised accessory for the landscape artist. The principle was simple. Make a small hole in the side of a darkened room and an image of the scene outside is thrown on to the

* Described in the *Codici Atlantico.*

opposite wall within. Replace the room by a box, the hole by a lens, and equip the outfit with a ground glass screen, and the artist can trace the design on to his paper.

The other phenomenon was the sensitivity of silver salts to light. When exposed to light they darken. This was demonstrated by Heinrich Schulze in 1727.

There is not much "pre-history" to photography, and only one important forerunner process. About 1800 Thomas Wedgwood (son of the potter) and Sir Humphry Davy were making experiments by placing plants and designs on glass upon sensitised leather or paper and exposing them to the sun. The paper darkened wherever it was not covered up by the design, and a primitive photograph was produced. But when the design was removed the light acted upon the previously covered spaces and the whole thing darkened and disappeared. It was the inability to fix the images they obtained which led these early experimenters to abandon work after publishing their researches in 1802.

The first photographs in the modern sense are now known to have been made by Joseph Nicéphore Niepce, a Frenchman, between 1816 and 1829. None of them survive. He also devised a kind of photo-engraving, examples of which may today be seen in the Science Museum, London. But the real photographs appear to have been both negatives and direct positives—that is to say, positives produced without printing from a previously made negative. However, they were not successful, and it is uncertain exactly how he worked. But he then met and entered into partnership with the famous Monsieur Daguerre, and by 1839 the latter had perfected the invention. It was announced in Paris during January of that year. In August the patent, having been thoroughly tested, was bought by the French Government and the secret published to the world. The Daguerreotype, as it was called, consisted of a photograph made on a sensitised silvered copper plate which had been developed and then made positive by exposure to the vapour of heated mercury. The display of detail was remarkable; but there were two serious defects, one of which remained irremediable and ultimately caused the process to die out. First, the image came out in reverse; but this was later corrected by using a prism. But the major

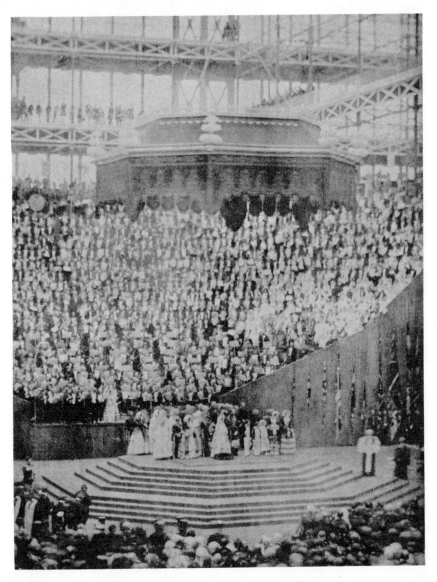

The opening of the re-built Crystal Palace at Sydenham,
June 10, 1854, by Queen Victoria and the Prince Consort.
Collodion photograph by J. Cundall and P. H. Delamotte.
Taken during the reading of the Archbishop's prayer.

Snapshot, or at least an exposure of very short duration.
Dated about 1857.

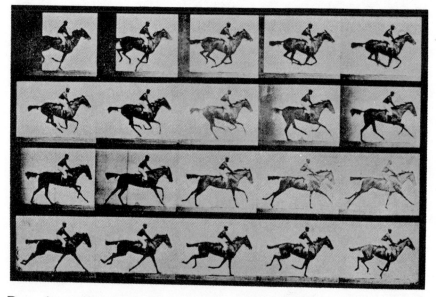

Dry plate photograph from "Animal Locomotion."
Taken by Edweard Muybridge between 1883 and 1885.

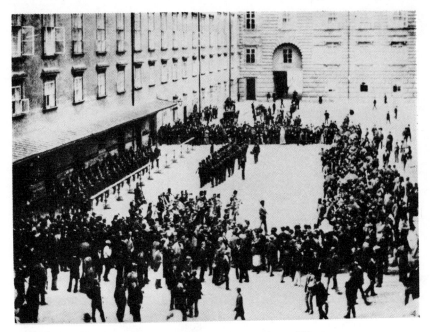

Vienna in the Seventies. "Burgmusik"—The military
band which played daily in the court of the Old Hofburg
(Palace).

[Photo: E.N.A.

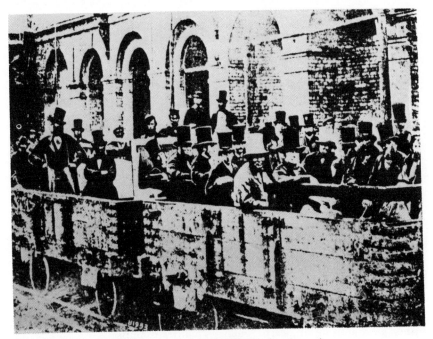

Mr. and Mrs. Gladstone on the London Underground.
An early Press Photograph. 1863.

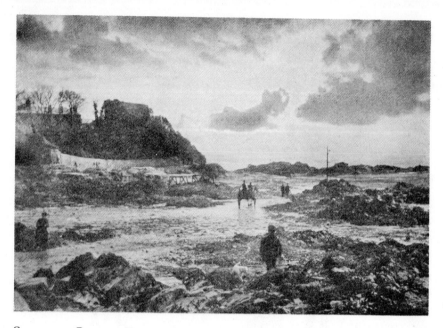

Scene at George Town, Jersey, in 1893. A typical picturesque print of the Nineties. A Salon picture.　　[Photo: Paul Martin.

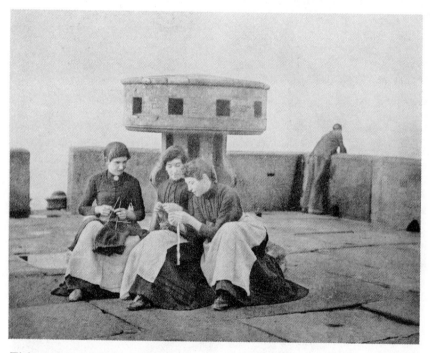

Fisher girls knitting at Scarborough. Another example of the pictorial in the last century.　　[Photo· F. M. Sutcliffe

objection was that the daguerreotype could not be multiplied. Each photograph was unique. It is here we turn back to the year 1833.

The scene is Lake Como and the actor a young English mathematician named Henry Fox Talbot. He had been trying to make sketches of the scenery with the aid of a *camera lucida*, a prismatic device recently invented which projected an image on paper which the artist traced out. He found this too laborious, and it occurred to him to try sketching with the *camera obscura*, which he remembered having tried some years before. " Such, then," he writes, " was the method which I proposed to try again, and to endeavour, as before, to trace with my pencil the outlines of the scenery depicted on the paper. And this led me to reflect on the inimitable beauty of the pictures of nature's painting which the glass lens of the camera throws upon the paper in its focus— fairy pictures, creations of a moment, and destined as rapidly to fade away.* It was during these thoughts that the idea occurred to me . . . how charming it would be if it were possible to cause these natural images to imprint themselves durably and remain fixed upon the paper ! And why should it not be possible ? I asked myself."

Talbot had never heard of the two Frenchmen, nor they of him. He went home to his country seat of Lacock Abbey and set himself to the solution of the problem. By 1835 he had succeeded in making a negative, and he then went steadily ahead improving his process until he heard of Daguerre's invention in 1839. He hastened to tell the Royal Society that he had been making similar researches for years, and exhibited photographs which were just as good as the Frenchman's. But there was an essential difference. Talbot had hit on the idea of making his photographic negatives on thin paper. By placing other sheets of sensitised paper beneath the negative he could obtain as many positive prints as he liked. It was true that the grain of the paper resulted in a certain loss of detail, but it was more than compensated for by the breadth of treatment it allowed and the opening up of

* The actual sketch book which Talbot used on this occasion has recently been discovered at Lacock Abbey by Mr. Barclay, of the Science Museum. It is now preserved in that collection.

the true direction of research for future workers. The fact that the Talbotype (later patented under the name of Calotype) could be indefinitely multiplied led to the whole subsequent development of photography. At the same time its depth and softness allowed much greater artistic possibilities.

The general evolution of photography from that year, 1839, until the end of the century was chiefly concerned with the reduction in the time needed for exposure, in fact the achievement of instantaneous and accurate shots. But parallel with this development ran two distinct lines of photographic thought, both of which were present at the outset. The daguerreotype, although it only continued for about a decade and a half, set the style for the accurate and detailed tradition, the tradition that aimed first and foremost at giving information. The calotype, rather well described as a " sun-picture " by Talbot, started the long history of so-called artistic photography, the photography intended for pictorial effect and expression.

The introduction of photography fits quite inevitably into the historical map. Industry and science generally were on the rampage. Machinery was over-running the world, the tempo of life was increasing, and the whole modern materialistic outlook was taking shape. The camera came to record it all. But one cannot help feeling acute regret that photography just failed to catch the outgoing Georgian era. It is surely not over sentimental to wish that the faces of Napoleon, Shelley, Keats and Byron, all of whom had only died in the previous decade, could have been caught by the camera. But it entered the scene within two years of Queen Victoria, and in many ways it is a typically Victorian phenomenon. It seems, on looking back, that photography simply had to arrive at that moment to accompany the growth of such a proud era.

A word, too, about the effect photography had on the Fine Arts. Within a very few years the whole course of painting was profoundly influenced by the newcomer. The minor branch of miniature painting was killed outright, as the daguerreotype provided a cheap and accurate substitute; and portraiture, in general, has perhaps never quite recovered

from the blow it received from photography. The general effect of photography was to enslave the weak academic artists, who were seized with envy, and to force the original creative minds into non-representational channels for ever.

Some second-rate artists thought that photography would ruin art. " From today, painting is dead," said Delaroche after seeing a daguerreotype. In general it merely created astonishment; occasionally it was denounced as immoral, and at first even disbelieved and treated as trickery. But the craze wore off fairly soon, and photography took its place as yet another scientific marvel in an age of marvels.

The first period of photography was from 1839 to 1851, the year of the Great Exhibition, which incidentally did much to popularise it. It was the time of the " primitives " and is sharply divided by the two rival processes of daguerreotypy and calotypy. The daguerreotypes were brought to a remarkable state of perfection, and, although a fair number of architectural and other scenes were made, the great production was in portraiture. They were often hand-tinted, and the detail became so minute that they will stand very considerable magnification. Stereoscopic daguerreotypes, very few of which are to be found today, also arrived in the middle forties and provide the most vivid idea of the appearance of our ancestors of that date. The sphere of personal commemoration was well served by the daguerreotype, and it flourished the world over.

The main artistic triumphs of the primitive period belong to the calotype, with its broader treatment and charming chiaroscuro effects. Talbot himself only managed to take three or four really beautiful photographs, as he was chiefly concerned with the technical aspect of the subject. It was a Scottish artist, David Octavius Hill, who, between 1843 and 1848, took some hundreds of the finest photographs ever seen in either his or any other day. It was in order to help himself paint an enormous group of the first Assembly of the Free Church of Scotland that he took up photography, and found a chemist named Robert Adamson to manage the technical side of the business. Hill was a poor artist, but his portrait photographs (he only took a few landscapes) will never be excelled. Lighting, posing and general composition

INTRODUCTION

are all delightful and, seen in the original prints, they possess a quite remarkable charm. Hill is, par excellence, the master of portrait photography.

Calotypy was never as popular as its rival; first because the craze was all for detail at the time, and secondly because Talbot was very strict about his patents. Hence the process never spread like daguerreotypy. But its practitioners, although few, included some great workers, and the name of Du Camp must be given a special place, as he was the first man to make a really large photographic tour abroad—in Egypt, Nubia and Palestine (1849-51).

The year 1851 saw the application of collodion to photography by Frederick Scott Archer. Although the glass plate had already figured in experiments it was Archer who first described the practical method of covering a plate with collodion to hold on the sensitive chemicals. When collodion is drying it goes through a conveniently sticky phase. When in this condition the coated plate is immersed in the silver salts, which cling to it. The plate is then exposed wet in the camera and developed immediately. The process was difficult and cumbersome, but for twenty years it was the universal method of photography. It is almost inconceivable, in these days of perfect cameras and automatic aids of every kind, that hundreds of men pursued photography with this bulky outfit. They scaled mountains and glaciers, they worked on battlefields, in balloons, in wild and unknown countries, and even under the sea.

The collodion process combined a far greater speed than the two earlier methods with the sharp detail of the daguerreotype, and within about five years it reigned supreme. The collodion period may be thought of as stretching from 1851 to 1871, from the Great Exhibition to the Franco-Prussian War. But there was still one serious drawback which was to postpone the ultimate and obvious stage of development. You still could not take moving objects. The plates were, despite the great progress, far too slow. However, it was the " grand epoch " of photography in that it saw the spread of the new science into almost every field in which it is now familiar. The possibilities of photography were now exploited so widely, and the whole subject became so broadcast that the emphasis

shifted away from artistic work to practical and topical achievement.

The history of the "topical" attitude in photography is a curious and absorbing study. "Topical" is perhaps a bad word to use when speaking of the opposite to the consciously posed and arranged photograph. But it implies the informality which led to press work and the so-called "candid" photography of today. Apart from freak anticipations, topical photography became quite well defined in the middle fifties. The topical and informal "mood" is clearly evident, and the tradition, once started, continued down to the present time without a break. The scene of the opening of the Crystal Palace at Sydenham in 1854 makes a convenient starting point and is of particular interest, as no one either knew it was being taken or in any way co-operated in its production. In 1855 Roger Fenton went to the Crimean War and became the world's first real press photographer.* The year 1858 saw the French photographer, Nadar, take the first aerial shot. Then, in 1861, the American, Matthew Brady, started taking the greatest early topical series we have. He and his assistants took seven thousand photographs of the American Civil War before it ended in 1865, and the prints have a quality which links directly with modern press work. Brady had much more of a flair for pictorial news than Fenton, and his work forms yet another milestone in achievement.

At this time everything that could be photographed *was* photographed, and in the collodion period the whole world was covered with photographers. It was the day of the great surveys, the patient recording of art treasures and buildings, and the general exchange and propagation of pictorial information. Between 1851 and 1871 the world became conscious of its appearance, and it only needed one more advance to catch movement and life.

But we have not said anything of the development of the other side of photography—the artistic. The collodion period included some of the greatest names in the whole history of the subject. Nadar (G. F. Tournachon) produced

* Mechanical reproduction in newspapers did not appear until later in the century, but wood engravings from Fenton's prints were published in the press.

hundreds of fine, dashing portraits besides making aerial photography practicable, and in 1854 the little " carte-de-visite " portrait was invented by A. Disdéri, and came to fill our family albums for nearly half a century. Two experimenters, O. G. Rejlander and H. P. Robinson, exploited the montage picture, and the former used thirty negatives to produce his famous " Two Ways of Life " in 1857. Gustave Le Gray made his marvellous landscapes, Adam Salomon took portraits only second to Nadar's, and Beato wandered from photographing the remains of the Indian Mutiny to the newly opened treasure house of Japan.

But perhaps the most astonishing character that enters our field during this period is Mrs. Julia Margaret Cameron. She was presented with a camera in 1864, and during the ten years during which she worked, produced a completely new kind of photograph. She took romantic portraits of the most compelling beauty, and re-created the subject-picture by posing her friends as illustrations to Tennyson.

After various attempts and mild successes there arrived in 1871 the invention that virtually closes the historical period of photography, and which made possible the fantastic variety of uses which we today associate with the camera. Dr. R. L. Maddox devised the method of combining the sensitive chemicals with a gelatine emulsion and produced the practical dry-plate. High-speed and all-weather photography arrived almost overnight. Now nearly all the later developments were in sight. Roll films, colour films, cinema films, X-rays, talking films—the road was clear for them.

But one invention, which was to form another minor revolution, entered quietly. The first mechanical reproduction of a photograph in a newspaper came in 1880 in New York. That led slowly to the whole vast production of process blocks which by 1900 were familiar to every book and newspaper reader in the world, and which killed the art which Mr. Paul Martin practised so skilfully in his earlier days.

Considering the spread of photography after 1871 it was very curious that the recording of everyday life, the " genre " painting of the camera, was scarcely thought of. It was not thought of because few people recognised its possibilities. It was Mr. Paul Martin, more than anyone else, who was

responsible for opening up what today is one of the major photographic fields. Mr. Martin is doubly interesting to the historian. He not only brought in the " Candid Camera " for our pleasure, but he is himself of particular significance. For he foresaw the ultimate ruin of his craft of wood engraving by the camera and process block, and was determined to enter and prosper in the practice of the very work that threatened him. He changed sides, so to speak, and gave us quite the finest set of informal studies of English life of the time. He ranks with Stieglitz in America and Atget in Paris, both of whom he preceded, and with whom he forms the vanguard of the great moderns.

Photography has its artistic practitioners and its topical practitioners today, and they pursue their paths with endless ingenuity and variety. They are the central motif, as it were, in the modern tide of photography, whilst the camera has branched out and become part of every scientific and industrial activity on the earth. They carry on the tradition of recording and commenting on the world as they see it, and unknowingly they compile a strange and wordless encyclopædia of history.

CHARLES HARVARD.

PART I. THE BACKGROUND

I

VICTORIAN WOOD-ENGRAVING

MANY, no doubt, will wonder what the above subject has to do with a book mainly devoted to the process of photography. The reason is partly historical and partly personal. I suppose I am one of the few of the old-time wood-engravers who still survive and, having changed from one profession to another, as my hobby became my livelihood, I can recall in person the great change from handicraft to mechanical processes of illustration. Before photography came on the scene and displaced wood-engraving the latter was the most convenient method of procuring illustrations in books and magazines, as it could be employed in conjunction with type. Now the illustrations are provided by a mechanical photographic process, which is cheaper and considerably quicker. This latter advantage is considerable, so let me give an example. No doubt it will be within your memory to recall the meeting of Hitler and Mussolini at Munich in September, 1937. It was reproduced in the press that same afternoon, a matter of a few hours. Had that occurred in mid-Victorian days a special artist would have been sent to make sketches on the spot, then hurry back to London, not by air, but by slow trains and slow boat, and then home. In the meantime the necessary wood block would have been prepared, and it would have been his job, or that of some other competent artist, to draw the incident on to the block. This is not so easy as it sounds, for all the work has to be drawn reversed, so that it prints the right way about. The next step would be the engraving of it, and, finally, an electro would have to be made. It is only then that it is ready for the press. All this work would take quite a week, as against a few hours of modern photography.

Those who remember the illustrations of the Victorian era will no doubt feel interested in knowing how they were pro-

duced. The wood-engraver of those days was an unknown person, and the skill of his craft known only to a few. As soon as I left school in 1880 the question arose as to what I wanted to be. At that time a friend of the family, on meeting me, congratulated me on the little drawings I used to make on the backs of envelopes when I wrote home from school. He said I was "artistic," whatever that meant. He invited me to his house to see some of his work, which was wood-engraving. I went, and had the pleasure of seeing him at work, and the work quite took my fancy. He saw my people, and he eventually agreed to teach me wood-engraving. A premium was to be paid, and my remuneration was to be nothing for the first year, 5s. a week for the second year, 7s. 6d. a week for the first six months of the third year, and 10s. a week for the last six months, the usual time of apprenticeship being five years; he undertook to see me through in three years.

From the first he impressed upon me what an apprentice in a firm has to go through. You are generally relegated to one of the members of the staff, who is supposed to keep an eye upon you, and on your part you must pick up what information you can from the others. The work being piece-work, it is not conducive to anyone wasting much time on you. My "boss," as I shall call him, was only nine years my senior, so we hit it off very well. He had quite decided views on the business, and complained that a lot of time was taken up in work not strictly engraving, in running errands and helping with this and that, so that progress is slow. He held the view that the first year should be entirely devoted to practice work, and, as I sat at his elbow, I was under his constant supervision, and was corrected as soon as I made a mistake. I soon found out how right he was, and progressed accordingly—so much so that I was able at the end of my first year to do a lot of work on the blocks which he himself was supposed to do.

He soon obtained work for me from the firms that supplied him with work, and this I duly executed, and proofed and delivered to the respective firms, bringing back the money I had been paid. This continued till the end of my apprentice-ship, after which time I stayed another three years in a

2

friendly way. From the first he made me take proofs of all I did, so that they would act as a record of my progress, if any ! I am very pleased that I did so, for I have a full record of what I did in wood-engraving during my first year, now close on fifty-eight years ago, and my album of these proofs is now deposited in the Victoria and Albert Museum so that anyone interested can see them.

Wood-engraving has seen striking changes from the days of Albert Dürer to those of Thomas Bewick and up to the

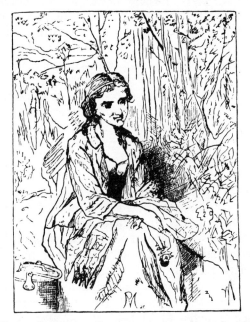

A " LINE " SUBJECT (A FIRST-YEAR EFFORT), 1881.

time when, having reached a very high standard of artistic and technical excellence, it practically passed out with Queen Victoria. Since the war some artists and others have tried to revive it in the " Bewick " style, under the name of wood-cuts or lino-cuts. One particular feature of this revival is that the work is executed a great deal by ladies, whereas this was unknown in the Victorian days. I only heard of one in all my twenty years' experience, and she turned out a failure, although she was an engraver's daughter. But there is no

reason why ladies should not be as good engravers as men, for it is a matter of touch and not of strength. However, they made it up in other ways and many became famous in illustrating books.

It takes many years of hard work to become a good artist and many more years to become a good engraver. Now the two are rolled into one after a very short time. The difference is because Victorian wood-engraving was a " reproductive art " whereas modern woodcuts is a " creative art." If I am a creative artist I take a piece of boxwood and upon its surface I trace two lines crossing each other. The boxwood we use is the very best Turkish boxwood. We always work on the end grain. Many pieces are sometimes glued together to make up to the required size; the pieces must also be of the same quality. I now take a graver and cut out those lines; this will take me about the same time as to draw them—that is, two or three seconds. You may remark that I have not followed the lines drawn very carefully, but I will reply, " *I* created those lines, and they express *my* artistic urge," etc. We next take a proof and we see a dark ground upon which the lines I *created* are white. They express exactly what I had in my mind, so it becomes a *creative art*.

If I am a reproductive artist I get *you* to draw two similar lines, and I take a very fine graver and cut a very fine line each side one of your lines and we call this outlining. It forms a very shallow trench all round that line, so I take another tool and do the same to the other line. The little trench outlining one side of the original line will enable me to make the rest dead true, and it now only remains for me to widen the trench and so help to cut away all the wood not required, leaving the only two original lines of yours in relief like a rubber stamp. I now take a proof, and there we have the two lines exactly as you drew them—that is, black lines on white paper, instead of white lines on a black background. *I* did not create the two lines, *you* did that; all I did was to reproduce them as you drew them, but it took *me* more than twenty times as long !

The question at once arises when we admire a wood-engraving, Is it the artist or the engraver that we admire ? Invariably it is the subject that attracts our attention—that is,

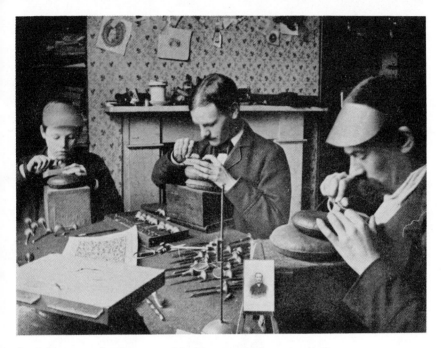

A master wood-engraver with his apprentices at work (1885). Paul Martin (on small easel) was his first apprentice (1880).

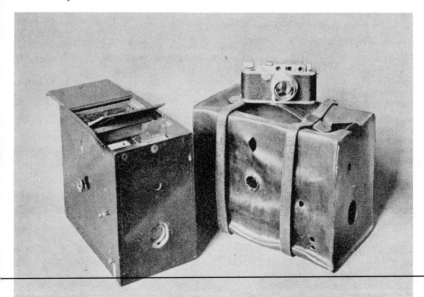

The Candid Camera of Paul Martin's youth and the Miniature of today. The leather case was of the photographer's own design. The camera was called "The Facile."

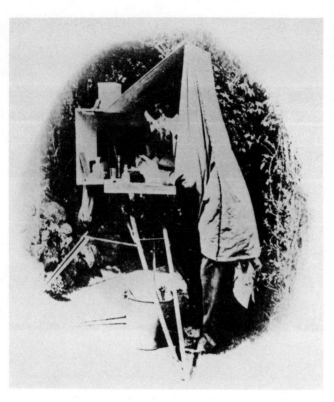

Photographic tent invented by W. White Rouch in 1859,
showing the method of working out of doors. [Photo: W. A. Rouch.

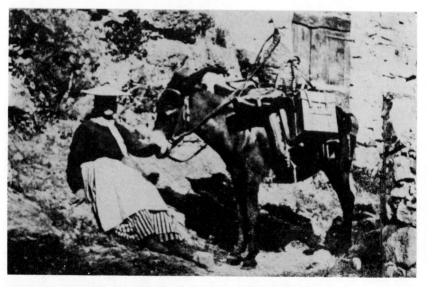

How photographic kit had to be carried in the " Field "
in the old days of wet collodion. Note the water bottle. Photo: W. A. Rouch

the work of the artist. The art of the engraver you will not be able to appreciate unless you are a skilled engraver yourself, and, the modern engraver of woodcuts being the creator of his subjects, he naturally confines his efforts usually to his limited craftsmanship. It is possible, of course, for a reproductive engraver to become a creative artist as well—in fact it is much easier than for a creative artist to become a reproductive engraver; but as a rule he remains an obscure craftsman.

Before such pictures as Millais's began to be photographed on to the wood, and the various tones had to be reproduced faithfully, all that was needed was the special skill required to draw the subject on to the wood block. The engraver did his part and that was all. In the early days the artist drew the design direct on to the wood, and later, when a medium was used, it had to have practically no thickness, as this would have interfered with the tooling, for the cuts are sometimes very shallow. In all this, however, the wood-engraver is merely concerned with the reproduction. When, however, it became possible to transfer a photograph of a subject on to the wood block an entirely new era started; for this purpose three distinct processes became available—a collodion, a carbon, and a silver bromide. The collodion was a positive on a black ground. It was now possible for any artist to produce work for illustrations; he could make his picture any size, in any medium, provided his dimensions were in proportion to the size required for the block, but on the other hand the wood-engraver's technique had to become much more creative. He had no lines to guide him; he had to produce tones that would convey *texture*, *atmosphere* and *perspective*, qualities so often lacking in woodcuts. It is often asserted that no two artists draw or paint alike, and the same can be applied to the wood-engraver. Take any given tone in a picture and probably there may be twenty different ways of reproducing that tone. Under these new circumstances the engraver inevitably ceased to be a mere reproducer; the conventions that had existed and which had cramped his creative spirit were broken; he became a part-creator.

It is not always appreciated that different countries produced their different schools or styles of engraving. The " American School " was noted for the fine key of their work, and also

their printing, of which there are excellent examples in *Scribner's* and *Harper's Magazines*. At the other end of the scale was the " German School "—good, clean, open work, with very high technical quality. The " British School " held the happy medium, but drifted towards the American as printing improved. This was first noticed in the *Strand Magazine*, and also in *Black and White*. The " French School " up to the eighties tended towards the " German School," but after that they were the first to become what we now call modern. There was always great rivalry between

A " TONE " SUBJECT (A FIRST-YEAR EFFORT), 1881.

the various styles, but none took any notice of the monster that appeared on the horizon with open mouth and that was soon to swallow the whole lot, and let loose the flood of illustrations which surround us to-day.

I had a strenuous time as a wood-engraver, as our work at the office (it would be called studio now) was partly concerned with Fleet Street—that is, news work. How well I remember the long hours that we had to work when the various wars broke out ! Once we worked three days and two nights consecutively, and we dared not close our eyes for fear they might become locked. We were paid for our work by the hour, on

the principle of no work no pay, no overtime pay, no extra for Sunday work. As I contributed my usual share at home, holidays were to me a very expensive item, a fortnight's loss of wages plus the expenses of the holiday. We had to work fifty hours a week, but many of the married men worked over sixty hours a week. One must remember, however, that the cost of living was less than it is to-day.

If you were to look at some of the engravings done during the rush periods you might well exclaim, " What rubbish !" and we should agree with you. Kindly remember the conditions under which they were produced, but we don't call them " Art." Engravers come under two distinct categories, the " pictorial " engraver and the " mechanical " engraver, and the two very seldom go together, their technique being entirely opposite to each other. The same applies to the artist who did the drawings for our wood-engravings. If he created the subject he is an artist, but if he should draw it from an object, as would be done for catalogue work or machinery, then he is only a draughtsman.

It must be remembered that while the artist is allowed to place his name to the work which appears in the wood-engraving, the name with sc. (*sculpsit*) after it is not the engraver's name, but merely that of the firm who employ him. The names of the actual wood-engravers are usually buried in obscurity: they leave no proofs of what they have done, their names are merged in the firm's. When the son of my late boss came to me in the hope that I could give him some details of his father's work, and show him some examples from the quantity of proofs he left behind, I could only point to prints that were most probably his. We wood-engravers, however, understood the necessity for this anonymity. It often happened that several engravers had worked on the same block at the same time; each had a section to do; it is then passed to others to do their bit until it is finished. Sometimes the block is made of sections that are bolted together. This bolting together requires the acme of precision, as, should the slightest join show, it will appear on the print. It is interesting even to-day to spot the work of the people who did different sections by the styles of their tooling. To us it is often as easy to identify as if they had left their finger-prints.

VICTORIAN SNAPSHOTS

The largest block that I have worked upon was a supplement of the *Illustrated London News* of November 29, 1890. It represents the Morning Room of the Reform Club. It contains forty portraits of the leading Liberal statesmen. It was drawn on the block by a Mr. Walter Wilson. The size of the block was 33 by 24 inches, made up of thirty separate pieces, all bolted together. Only four engravers participated in the engraving of this block. A Mr. H. B. Woodburn engraved all the portraits, and myself with two others shared the other parts, figures and background. It must be evident that it would be next to impossible to manipulate such a large block in that state, so for convenience' sake it is made up of smaller blocks that bolt up together of a size of about 5 by 4 inches. You engrave the part entrusted to you to within, say, ½ inch of the edge, when you bolt on to it the portion that you require, and having crossed the joint you then unbolt the section and carry on. This is repeated at all joints. Most engravers are better at some subjects than others, so the work is distributed accordingly. This can only be done when time will allow for this procedure. In the case of rush " news " work which has to be executed within, say, a couple of days for a double page, the following procedure is adopted. As soon as the artist has completed his drawing on the block it is passed on to the engravers, who set the work all down the centre joint of the block to a width of, say, ½ inch each side of the joint. The block is then unbolted at this joint and the two halves are similarly treated by two competent engravers. This is repeated until all the joints have been dealt with. By this time the original block is divided into its component parts, which are distributed to different engravers, whose job will be to carry on the work set from one side to the other until the section is finished, when all the sections will be rebolted together, making the finished block. This can be seen at the Victoria and Albert Museum in the engraving section. The block is now ready for a proof to be taken, and any retouching that may be required is duly carried out. It takes an expert to proof a block properly. It will be evident that working under such rush conditions is not conducive to the best work. If you were to look back to some of the *Illustrated London News* or *Graphic* Boer War pictures you would probably

8

exclaim, " What rubbish they turned out in those days !" overlooking the fact that probably the poor engravers had worked for perhaps two days or more without stopping.

Most wood-engravers possessed a large variety of tools made up in sets so as to cope with the variety of work required. All engravers could not sharpen their tools properly, and for that reason they were very much like razors. A publisher of modern woodcuts told me recently that he thought one of the diffi-

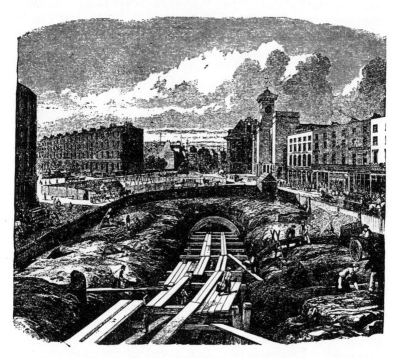

A TYPICAL ENGRAVING FROM AN ILLUSTRATED PAPER

culties of modern engravers was that they did not know how to keep their tools up to the mark. In the old photograph of the three engravers at work you will get a very good idea of how they handled their material. The engraver controls the block on the sandbag with his left hand; the extended thumb of the right hand is the only guide he has for his work. You will see also that the tools have only half a handle; this is in order to clear the tool from the surface of the block, otherwise

he could not lever the tool out of the cut he is making, although very shallow. A good tool, moreover, should never have a straight " belly," as the under part is called, but should be very slightly curved.

The wood-engraver usually makes only very short cuts at a time, at the most $\frac{1}{16}$ inch. As the little chips come up on to the tip of the tool or on the block he blows them off, otherwise they might cause him to slip. The sound that an engraver makes when cutting a " tint," such as a sky, is like the faint sound of a watch—" Click! click! click!" This is why he is known in the trade as a woodpecker. Supposing he has to engrave a round dot, say a full stop, the block or the tool will have to travel an entire circle before it is complete, a long time for a small item. If it should be a round white dot on a dark ground, he will dig the point of the suitable tool into the surface of the block, and rotate the block with his left hand.

The engraver naturally wants a good light, concentrated on his work. An opaque blind generally covers the lower part of the window at which he is working, at about the level of his eyes. He usually wears an eyeshade, which keeps the light off his eyes and makes his work more restful. For very fine work he might use an eyeglass like a watchmaker, sometimes on a stand. At night-time we work by artificial light—a gas burner, with a gas mantle when they came in. At a distance of even two feet the light would be much too weak, so we placed a glass globe filled with water in front of the light, which acted as a condenser and magnifier and helped to project the light on to the work. The water is tinted pale blue, which makes it very restful for the eyes. I have had to work for three weeks by artificial light during a very foggy period; like most engravers and watchmakers, I am noted for my good eyes.

Few wood-engravers realised what photography was going to bring in its train. I knew that monster when he was only a sprat, for I took up photography as an amateur in 1884, when the dry plate was just out of its shell. When the monster made a lunge at me I dodged him and clung to his tail and am still hanging on. It was in 1885 that I first saw what the photographic process could do, and it was in the *Photographic Almanac* of that year that T. E. Ives had as a supplement some of his results in orthochromatic photography, printed in

half-tone. In 1882 Meisenbach had patented a half-tone process, but Ives in 1885 brought out his cross-line screen, which is the origin of the present-day method. It was not, however, till towards the end of the century that it began to make its influence felt. This was certainly due to the improved printing methods adopted, as printed in the ordinary way with type it was a failure. The Germans and the Americans persevered and conquered, and finally, in the twentieth century, threw the wood-engravers completely out of work. Nearly all of us attended the classes at the Bolt Court School of Process, but to no purpose. Some are now employed by process firms as their tooling is a great help in many ways; but as illustrators in the old sense our work was over. Now rotary photogravure is casting a shadow on the half-tone process. Where will it stop?

It seems to me possible that the viewpoint of the early photographers was influenced largely by wood-engraving, because so much of their work had to be interpreted by wood-engravers, and they therefore sought to give us the kind of picture as an original that artists had previously furnished from quick drawings or out of their heads. I do not think there is much doubt that my own leanings towards snapshots of everyday life were the result of my close connection with the Press. Indeed, it was in this kind of photograph that I first began to turn my hobby to commercial use. That, however, belongs to a later chapter.

[*The first two wood engravings in this chapter were executed by Mr. Paul Martin within his first year's apprenticeship. Electros of the blocks were made from the original blocks. He traced the subjects from magazines and transferred the tracings on to the wood block, then drew them and afterwards engraved them. He was then seventeen years of age.*]

II

MY FIRST PHOTOGRAPHS

EVER since I was a small boy photography fascinated me, and I well remember my first visit to a photographer's to be " taken " with my parents. It was not what he said that impressed me, but what he was doing under that black cloth. Why was he always going into a small room by the side of the studio ? When it was over he told us to wait, and here I had my chance to investigate. I lifted up a corner of the black cloth, but there was nothing to see; evidently he had taken the inside away to that mysterious room. Presently he came back, holding a piece of wet glass which he placed against his sleeve and asked my people to see for themselves that it was all right and that their boy had kept quite still.

I was told to go there a few days afterwards and that he would hand me an envelope, and I well remember his telling me that I was on no account to open the envelope in daylight. When I arrived he was busy with some frames which were displayed on a board resting on trestles outside his shop. As he picked up one of the frames he turned his back on me whilst he did something at the back of the frame, and quickly closed it up again and replaced it on the board. This excited my curiosity, so I used to go and watch him, and when the sun was out he would take the frame just inside the doorway of the shop, with his back to the street, and go through the same performance. This all seemed very mysterious, and a second visit some time afterwards to fetch a group of my people, taken with some friends, did nothing to enlighten me.

Like all boys of my age I was mad on making experiments, and at the chemistry class at school we made our own working models, fireworks, etc. One day at a shop near the school I saw a penny packet on the outside of which was printed, " How to make your own Photographs." That day I was a penny short in the money that was given me for my lunch. When I

opened the packet it contained a piece of glass 2 inches square and a card the same size, and in a small piece of tissue paper was a pinch of reddish grit. In the instructions I was told to dissolve the crystals in a tablespoonful of water, and, having cut up some notepaper the size of the glass, float each piece on the solution. Then, being careful not to expose it to the light, you drained the paper and dried it by the fire, when it would be ready for use. I did all this, and according to the instructions borrowed a piece of lace and placing it on the glass laid the yellow side of the treated paper in contact with it, and lastly placed the card on top. You then tied it up with fine string round the edges to ensure contact and placed it outside in the sun. When the paper had darkened you took it indoors and thoroughly washed it under the tap and then dried it. I obeyed all the instructions carefully, and I was successful: the light pattern of the lace came out on a dark ground. I was disappointed, however, in not being able to make copies of the photographs, or to photograph myself. To do this, the instructions said, you would have to go to a professional photographer to have a negative taken, and the charge would be ninepence. This terminated my experiments, for in 1874 spending ninepence on photography would have meant going without lunch.

Two years later we were in the same difficulty. A friend and I had been to a fair near Battersea Park, and on our way home a man pounced upon us and wanted to take our photograph. " Surely you have got ninepence between you," he said. We told him we had not, but nevertheless he placed us against the fence and told us we would make a fine picture. " If you have got sixpence that will do," he exclaimed, and disappeared into a kind of portable dark room. Before long he came out with something hidden under his coat and vanished under the black cloth that covered his camera. What he did underneath I don't know, but he bobbed up and down a good deal, and when he reappeared he asked us to keep perfectly still. We did, and after a moment he came out from the cloth and disappeared head and shoulders into his other sanctum. Before long he came out with a piece of glass covered with a white scum, and, pouring something over it from a small bottle, the cloudiness cleared off. Then he placed it against

his faded black coat sleeve for us all to admire. We hardly had time to look at it before he dried the glass, and coating it with black put it into a metal frame round which was a wooden frame. At last it was all over and we were able to pay our sixpence, take it away, and feast our eyes on it.

My third experience carried me a step further. A friend, knowing that I was an apprentice at wood-engraving, showed me one day a small print. Knowing that photographs were always on glass or on cards in an album, I could not at first believe that it was a photograph at all, but he said he was working for a man named Miall who made " dry plates," whatever that meant, and that the process was quite easy. That settled it; it was 1883 and I was in the last year of my apprenticeship, and I had caught the *Bacillus photographicus*. A few days later I had to go up to town to deliver some work, and I had a good look at the book shops in Ludgate Hill. I was lucky. Burton's *A B C of Photography* was just out at 1s., and at last I discovered what " dry plates " were. It was written in such an easy style that I learnt it off by heart as an actor does his script, especially the exposure table, the first of its kind, and which I found of great help in my early work. It was only the last chapter that damped my ardour; it was on " Instantaneous Photography," and the author said it was the most difficult branch of photography, and his advice to those who thought of taking it up was " Don't." Moreover, it would cost £4 to £5 to buy the outfit, and I decided that this branch of this new hobby was not for me.

I soon found that even if I gave up instantaneous photography my new pursuit was going to be expensive. On the back of a new twopenny newspaper called *Knowledge* I found an advertisement of a firm called J. Lancaster and Son, of Birmingham. They sold three types of cameras: the Merveilleux at £1 1s., the Meritoire at £1 10s., and the Instantograph at £2 2s., all complete with a double dark slide, a chromatic lens, and a folding tripod. Supplies were a further problem, but I was lucky in finding a shop between Waterloo and Westminster Bridge Road in the New Cut, now known as Lower Marsh, which led to the Canterbury Music Hall. As I was walking along between the barrows which lined both sides of the road the words " Photographic Chemist " caught my eye

on one of the shops. I pushed my way on to the pavement between the cabbages and rhubarb, and to my surprise found the shop full of customers. The boss sat at a raised desk and was taking charge of the cash. He had a short black beard and wore what was known as a smoking cap, but without the usual tassel. " Vat you vant ?" Mr. Jonathan Fallowfield asked as he caught sight of me. " Have you a price list ?" I asked. He looked disappointed. " Give the shentleman a brice list," he said to one of the assistants. The crowd was apparently full of the " ninepence as you are " type of photographers, spending Saturday afternoon buying supplies for the Sunday trade, and to Mr. Jonathan I must have looked rather a dilettante.

I worked extra time at my wood-engraving, building up a photographic fund, and the next year I bought a ¼-plate Meritoire camera and soon added a wide-angle lens with rotary stops. The Meritoire had only one aperture of about F.22. Before long the firm I was working for utilised several of my photographs and paid me for them. The plates that I put into my three double slides were made in two grades, Slow and Fast, but both kinds fogged easily, did not keep well, and the film was liable to frill at the edges and sometimes leave the glass altogether. On the whole, the slow were more dependable and less coarse in grain than the rapid, and they kept better, but there was not much difference in their speed. There were only two developers then: ferrous oxalate, which gave you a nice blue-black negative of fine texture if you used rain water; and the other was pyro ammonia, which was not so simple. You had to add more pyro or ammonia as required, and the image came up slowly and built up gradually, not as to-day when you get detail first and density afterwards. No preservative was used, and the developer, which at the beginning looked like water, soon had the appearance of weak tea and before long beer and then stout. It stained the fingers badly, and had to be thrown away at frequent intervals before fixing the plates with hypo.

There was only one kind of printing paper in general use, an albumenised paper which you cut up yourself and often had to sensitise as well; this paper needed a good strong negative. Carbon was only just being introduced, and Platinotype was

still the hot process, for which you had to obtain a licence.
Bromide paper had also only just appeared, and the results
were flat and poor. It was used chiefly for enlargements
that had to be worked up. For plates, and also for the more
sensitive types of paper, the dark room was always the problem.
One could fill one's slides in the dark of one's bedroom or in
the coal cellar under the stairs, but for developing one had to
have some kind of red lamp. The simplest was merely a hock
bottle with the top and bottom cut off; with a japanned tin
base, and a tin cap to fit on to the neck, it was sold at 1s.
The ventilation was, however, always unsatisfactory; the
candle or night light inside soon filled the bottle with smoke,
and before long melted away. I had to invent a lamp for
myself.

In 1886 I replaced my ¼-plate Meritoire with a ½-plate
Instantograph. At last I had a camera with a shutter, and
took larger pictures. But there were always the plates to
change, either under the bedclothes or in a temporarily fixed-
up dark room. Local dealers were still unreliable and seldom
had what you wanted, and this, no doubt, accounts for the
fact that from 1884 to 1888 I never came across a single other
amateur photographer. Facilities are everything in popu-
larising photography, and now your camera can be the size
of a cigarette lighter and sometimes easier to work.

Though I never came across any other amateur photo-
graphers, I added to my knowledge by getting the *Photographic
Almanac* of 1884 and the *Year Book of Photography* of 1885,
and a copy of the *British Journal of Photography*, but they
were all too advanced and related almost entirely to professional
work. It was not till I joined the firm of R. Taylor and Co.,
in New Bridge Street, E.C., that I found myself in the heart
of newspaper-land and saw all the new publications as they
appeared. The *Amateur Photographer* for 2d. was just out,
and through its columns a large number of Amateur Photo-
graphic Societies were being created, including the West
Surrey Photographic Society, that I myself helped to found.
Amateur Photography had monthly competitions and was the
first paper devoted to the interests of amateurs. It gave
medals for what it called " artistic " photographs. I sent
one in, and mine secured the medal; it had a nice blue ribbon

and a clasp to it, and was presented to me with some charming compliments.

Professional photographers had two papers, the *British Journal of Photography* and the *Photographic News*, and soon other papers like *Photography* and the *Photogram* appeared. Of the photographic societies the leading one was the Photographic Society of Great Britain, which eventually became the Royal Photographic Society of Great Britain. It was established as early as 1849, and held monthly meetings and yearly exhibitions at 5A, Pall Mall. The South London Photographic Society, established in 1859, also held meetings once a month, at the Society of Arts, John Street, Adelphi. In 1879 the Photographic Club was established, and in 1882 the London and Provincial Photographic Association, which was looked upon as the Fleet Street of photography. Though they held no exhibitions and took no great interest in pictorial work, I found when I joined them in 1897 that I soon became acquainted with the leading men of the photographic press world. In 1884 the provinces alone had over two dozen photographic societies.

On the whole, I found the exhibitions of the Photographic Society of Great Britain in the middle eighties too full of professional work. There were frames full of *cartes-de-visite* and cabinets, and the main object seemed to get a high glossy surface with enamel collodion, and to emboss it, making it look as if it were suffering from a huge blister. In the early nineties a number of members broke away and formed exhibitions of their own at the Dudley Galleries in Piccadilly, called the Salon and later the London Salon. One great feature of these early amateur photographers was that they did all the work themselves; professional help, indeed, would have been hard to find. Prints, too, took longer to make, as the printing was done by daylight; it often took me the whole summer to make six good exhibition prints, especially if they were carbon.

My own great ambition in amateur photography was to produce something new to show to our society, and in our exhibitions we were urged on by having some of the best workers in pictorial photography, notably Colonel Gale and George Davison. By this time I was working a whole-plate

camera with only two slides. This meant that I could only take four photographs per outing. My work, then, was very different from " snap " work, and grew gradually in size until it reached 15 by 12 inches. After trying matt paper I eventually used very rough Whatman drawing paper, which I had to prepare myself. After gathering a good crop of medals, I was an absentee from the Salon for forty years, but exhibited again recently.

Had I had independent means I should probably have pursued exactly the same road as the other pictorial photographers of the nineties, whose ambition it was to make their photographs as much like a painted picture as they could. Careful composition, superimposed clouds, soft printing and other technical tricks were used to produce effects which were certainly beautiful, but which took the photographer further and further away from life. I was for a time as keen as anyone and fairly competent, but it was an expensive hobby and never had the same interest for me as the real snapshot—that is, people and things as the man in the street sees them.

In the late nineties I and another member of the West Surrey, who had been apprenticed to one of the leading South Coast photographers, decided on a venture of our own to help amateur photographers. We founded the firm of Dorrett and Martin at Wandsworth Common, and had show-cases at various stations on the Brighton line showing the kind of work we could do to help amateurs. It turned out a complete failure, and, as very few people visited us at Wandsworth, we opened at 60, Strand. Here we embarked on Press photography, and displayed the results in our show-cases; and, as we shared the building with Mr. C. B. Cochran, the variety agent, so many people stopped to look at our work that the police told us we were causing an obstruction.

III

THE HAND CAMERA

THE birth of the hand camera, about 1890, formed an important era in the history of photography; it implied the progress of instantaneous photography, against the use of which Burton had only a few years before so emphatically warned the amateur. For some time previously various kinds of hand cameras had appeared: one was collapsible and fitted into a kind of watch-case, another fitted into a bowler hat with the lens protruding from the top; still another was intended to be worn under your waistcoat, the lens protruding from your button-hole. This last was a circular arrangement fitted with circular plates. The exposures were made by pulling a string dangling from under your waistcoat, and a similar arrangement rotated the plate for the next exposure. A friend of mine, also a member of the West Surrey Photographic Society, had one, and took a snap of me unawares. As he was short and I rather tall, what was included on the plate was pure guess-work; I had the pleasure of seeing what I looked like " beheaded."

Soon another kind of hand camera appeared on the market called the " Facile," manufactured by Miall, the maker of the " dry plates." The camera was sold by Jonathan Fallowfield (same Jonathan), and my friend who had the waistcoat camera bought one of these too. It was known as a " Detective " camera, as it was camouflaged in a brown-paper parcel with a strap round it. A hole was made for the lens and one for the viewfinder. It was not of the present bright vision type, but simply a small lens that reflected the image upwards on to a small ground glass, and unless the light was very bright it was almost impossible to see what you were taking. Nevertheless there was something that appealed to me in this camera, after my experiences with a cumbersome whole-plate camera, and I bought one. It was called " The Facile." It measured

8 by 6 by 11 inches, and was well made in mahogany, and takes twelve ¼-plates which are placed in separate sheaths. These sheaths fit loosely into two grooved magazines, one forming the top half of the camera and the other the bottom; these are actuated by a rack and pinion. When you turn the knob the first of the plates, which are all in the top half, drops into the lower chamber, where the exposure is made. By turning the knob the next plate comes down in front of the previous one, and a number indicates the plate that is ready for exposure. I found it very convenient, as I could load up with different plates for different exposures, isochromatic or fast, as I wished. All that was necessary for this after the exposure was made was to reverse the camera gently and work the pinion accordingly. The lens was an ordinary R.R. working at F.8, which in those days was considered a very fast lens. Out of curiosity one day I measured it up to confirm the value of the largest stop, and it came out at F.11, which is only about half the speed. I told Mr. Miall, and he said: " Why, you know why that is so, for if I stamped them F.11 I would not sell one."

The shutter was simply a fan-shaped piece of metal that worked between the lenses, and was made to pivot by two rods that projected at the side of the camera, and when you pushed one in the other came out. I soon found that when you pushed in the rod like a button of an electric bell with the forefinger of the right hand, holding the camera in the left, you got 90 per cent. of the exposures spoilt by movement. I therefore did away with one rod and fitted instead a safety-pin to a catch, *a la* Heath Robinson, and holding the camera with the right hand by the strap handle and resting it on the open flat left hand resting against the body, I was able to press in the pin and make the exposure by gently using the middle finger of the left hand. It was as if the camera rested on a rock and I never got a move. I once asked Mr. Miall what he thought was the quickest exposure you could make with this shutter, and he said one-twentieth of a second, although I should say that in most of my exposures they averaged a quarter to one-tenth of a second. Other makes whose shutters are an unknown quantity often work at one-fortieth or one-fiftieth of a second, which meant that I was giving my exposures

more than ten times the exposures given by other cameras. It was not that my plates were very fast; on the contrary, compared to present-day standards they would be classed as slow, and the lens of my camera was just an ordinary R.R., which we nicknamed " ginger-beer-bottle type," for anastigmats were unknown then. Now I have a Zeiss 4·5 in 3½ by 2½ minimum Palmos camera fitted with a quick wind focal plate shutter, and yet I get four out of every dozen moved unless I work the shutter at one-fortieth or one-fiftieth of a second; and with a V.P.K. I get eight out of every twelve moved under the same conditions.

When working the " Facile," which is now, alas ! out of order, I used to find that everything beyond 25 or 30 feet was in focus, but anything nearer was out of focus, so as the camera had no focusing arrangement I had to make one. The opening that indicated the number of the plate being exposed was square, so I soon cut a triangle into the apex and another at the bottom, making it a lozenge-shaped opening. Then, instead of putting a plate in the sheath, I put a ¼-plate opal to act as a focusing screen. I wedged it in the groove of the lower box and removed the sliding panel at the bottom of the mahogany case, and so by lifting the hinged cover of the grooved box I was able to see the projected image quite clearly. At the various distances 3, 4, 5 and 6 yards, I made a mark with a pin in the apex of the top and bottom of the opening denoting the number of the plate. Each separate distance was recorded in the same way, and all I had to do, when the carrier with the plate had dropped, was to turn the knob to the required distance. Seven feet was the blind spot, as I called it, for that was the distance at which the next plate would drop in front of the one that you were exposing.

Holding the camera sideways prevents the sheath and plate falling with a resounding thud, which is sometimes most inconvenient. Mr. W. Fergusson, K.C., relates how when as a young man he was an enthusiastic worker with the " Facile " camera, he conceived the idea of having it in court one day to take a snap of the man in the dock unawares. He arranged the " Facile " in such a way that it would not be noticed, and the exposure was duly made. But when he came

to change the plate without disturbing the camera there was a very noticeable thud, and the judge and counsel all looked somewhat puzzled. But nothing was said and the second plate was exposed, which in its turn had to be changed. This time, however, the thump was louder than ever, and the judge looked up again. " What is that?" he asked, but no one could give any answer, not even after looking under the benches, etc. At this point Mr. Fergusson thought it as well not to change the plate again.

The disguise of the camera in a brown-paper parcel was all very well until I was caught in a heavy shower of rain, and then I thought otherwise. I went to a neighbouring harness-maker and asked if he could make me a black leather case for it, which proved to be a better disguise than the paper parcel. It is impossible to describe the thrill which taking the first snaps without being noticed gave one, and the relief at not being followed about by urchins, who just as one is going to take a photograph stand right in front shouting, " Take me, guv'nor !"

The view-finder of the " Facile " was provided with a metal flap which hinged over when not in use, and when raised acted as a shield to the lens of the view-finder, thus helping the brilliance of the image, which at the best of times is never too bright. The only remaining fault of this camera was that the R.R. lens and the view-finder were both exposed to the weather and also to the gaze of inquisitive onlookers. This I remedied by a thin strip of ebonite about 2 inches wide and 4 inches long, which moved easily by suitable grooving, so that when the flap (which had suitable openings) of the view-finder was raised it raised also the ebonite flap, a piece of string connecting the two. A piece of elastic, suitably placed, brought it down again when the flap was closed.

It is a well-known fact that if you cover part of the lens at the top, a corresponding amount of light will be taken off the sky, and this comes in very useful in the case of skies that stretch across the plate. You can thus reduce the exposure of your skies and obtain clouds without the help of a filter. I found out the exact amount that one could lower the ebonite flap, and drilled pinholes at the side so that by inserting a pin the flap could descend to its proper distance and stop there

as long as the pin was not removed. This proved very useful. I also made one more improvement. On the pin that acted on the shutter I made a small cut on the under-side so that by unscrewing it it would come out on top and be caught up by the spring catch of the shutter, keeping the lens exposed and enabling me to make time exposures with ease. The camera is provided with a safety shutter to enable you to make changes without the light affecting the plate.

I feel that I have introduced so many gadgets and alterations into my " Facile " camera that it ought to be called the " improved ' Facile,' " but it was certainly the reason why I got so much better results than the other users of the camera. Without my improvements it would have been impossible for me to have made the series of " Street Characters " that I did, or the stormy studies that I made in drenching seas and rain. In my London by night subjects I generally found a spot where I could place my camera, or some handy railings, like those of Leicester Square, on to which I could strap it. Sometimes I would take my whole-plate camera tripod and rest it on that, but useful places like the parapet of the Thames Embankment or the back of a seat were generally sufficient. On the whole, I feel any success, whether with a tripod or hand camera, that I have achieved in the pursuit of photography, notwithstanding the slowness of the plates and the very restricted range of paper, is due to the fact that I never exposed unless I could give the subject the full exposure it required. Were it not for the " vigorous " brands of paper now on the market, 90 per cent. of the negatives now taken would be unprintable—except those taken with newest miniature cameras such as the Leica, etc. This latter branch of photography has, of course, its own technique which must be faithfully adhered to: it represents the advance of nearly fifty years of photographic improvements, though the gap of years seems now quite small.

My firm were not slow in estimating the possibilities of my " snaps " as material for the artists to draw from. They used to get me to go to various places and take " snaps," from which the artists would compose suitable drawings to be ultimately engraved. For this purpose they would arrange the facilities with various authorities. In this way I took

snaps at the Bank of England, the Woolwich Arsenal, Greenwich Observatory, hospitals, Lambeth Palace, the Tower, etc. Having developed the plates I would pass on to them the negatives to be dealt with by them.

By 1895 the progress of process engraving had begun to make itself felt, and my hours of work were reduced; instead of leaving off at 7 I left off at 6, so I had more time to devote to photography. One evening I was caught halfway along the Embankment in a downpour of rain, and I could not help noticing the effect of the reflected lights on the pavement. I was always looking out for new ideas, so the next wet night I was on the Embankment with my " Facile " and my whole-plate tripod upon which I could rest it. The only people about were on the seats, London's outcasts, and I was fortunate enough to be able to make a trial exposure of about ten minutes. When I developed the plate I found that the exposure was not far out, but the halation of the simple gas jets in the lamps was something tremendous, like Saturn's rings, and all down the roadway were dozens of streamers, produced by any vehicle carrying a lighted lamp, although the lamps were lit only by a candle. Both these faults had to be remedied. The remedy for the first was to use backed plates, and the second could only be obviated by covering up the lens when lights appeared in the distance and until they had passed me. This I did, and when I developed the plate I found the faults negligible and made a print. I took the print to the London and Provincial Photographic Association, and the editor and sub-editor of *Photogram* were so much impressed by it that they persuaded me to go out on a dozen or more wet nights and make a set of slides. I persevered, and won the Royal Medal at the Royal Photographic Society with them, as well as placing eight of them for reproduction with the Autotype Company in Oxford Street on a royalty basis of 15 per cent. At the same time I sent some pictorial work to the Salon, and also won the first prize of £5 5s. in an important competition connected with Christmas cards.

When I visited the Royal Photographic Society's exhibition I was surprised to find two extra large enlargements of my London by gaslight subjects made by the Autotype Company. When my slides were put on the screen each evening most

people remarked, " An absolute fake!" but the editor of the *Amateur Photographer* said I ought to treat this as a great compliment, and asked me to write two articles for his paper. When I received the Society's medal the President, Captain Abney, mentioned that never before had the judges such a difficult task in awarding it, as there had been three sets of slides of outstanding merit sent in. The other two were a wonderful set of slides sent in by Mr. Lodge, the first to record birds in their nests and natural surroundings, and an equally wonderful set of slides sent from Germany, illustrating the wonders of the X-ray, coins in purses and the bones of the hand, etc. They had decided after long deliberation to give the medal to me, because my slides were not only original but showed an artistic merit lacking in the others.

All these subjects were taken with my " Facile " hand camera resting on the tripod. The exposure, with an open stop F.11, varied from ten minutes to half an hour, and I always started my exposure whilst there was just a ghost of daylight left in the twilight, about one hour after sunset. I used Edwards's Isochromatic Plates, developed with a very weak Rodinal developer for half an hour, each plate separately. The slides, which subsequently travelled all over the country, were on Alpha Lantern Plates, developed for blue tones. The cover glass was an ordinary lantern plate, fixed and well washed and then stained a pale warm yellow colour to give the gaslight effect.

At that time people had not forgotten the Fenian outrages that had taken place around Westminster, so that I excited a certain amount of curiosity, not to say suspicion. When I was making my first exposure on the Embankment in the pouring rain a bulky City policeman all complete with beard approached me and said, " What are you supposed to be doing?" " Taking a photograph," I answered. " What!" he exclaimed. " At this time of night and in this rain?" " Yes," I replied. " That's why I am taking it." He said nothing more but stood by with his arms folded under his huge cape and just slightly nodding his head, as much as to say, " Poor fellow! No doubt queer in the head!" As each cab passed my hand would shoot out and remain in front of the lens until it had passed. This no doubt puzzled him very

much, so he went and leant against the parapet for support, keeping a watch on me all the time. When I thought that the exposure had been long enough I turned towards him and waggled both my hands at him. Then I grabbed my camera and tripod and made towards Waterloo Bridge. After I had covered about 200 yards I turned round so as to have a final look at him. To my great surprise he was not more than 30 feet away, so I put on the pace and reached Waterloo Bridge first, this being, I believe, outside the City boundary and his beat. When I was doing Trafalgar Square they never interfered, but they nevertheless kept a sharp eye on me. The picture of the lion at the base of Nelson's Column, with Whitehall in the background, shows just by the lion's paw a policeman's helmet. The exposure for this picture was fifteen minutes and the policeman never moved all the time. The reason is to be found in *Tit-Bits*. " Is sleeping in the open detrimental to health ?" was one query, " Of course not, for where will you find a healthier body of men than our City Police," being the answer.

The subject of night photography was soon taken up in America, and one of their leading men made a set of New York by night, but with this difference, that he took his when there was deep snow on the ground. They made an excellent set, and when he was complimented on his success he was kind enough to say that the compliment was not due to him but to a London photographer. All he had done was to go on from where I had left off. We are not so fortunate, or unfortunate, in getting a lot of snow in London, for when we get a slight fall in the day-time it soon goes over the parapet. The only chance I had I made the most of. It had to be on the Embankment, as anywhere else the snow becomes slush in a few minutes. Being at a friend's house one evening and noticing a slight fall of snow with the moonlight shining on it, I rushed home and got my " Facile." I made for Wandsworth Common, but there was nothing worth wasting a plate on there. However, in the distance I saw some lights. It was the Surrey Tavern in the Trinity Road. The next thing was to find a suitable foreground. There it was, just a solitary tree, so I got my camera, rested it on the tripod stand and surveyed the scene. It was 10.30 p.m., freezing

hard, and the moon was full. I had once read of somebody taking a moonlight effect of the Alps with a one-hour exposure, so I decided to give this one hour. After what seemed to me several·hours I ventured near the light to see how much more it required. The time was 10.45, so that it needed a further forty-five minutes. I was nearly frozen stiff, so I started to run round the bushes away from the camera. It was not long after, being some distance away, that I noticed that the scene was not so bright and the lights were being put out. I could not make it out, but remembered that public-houses sometimes do put some of their lights out before closing. This would not be so now, as they did not close till 12.30 or more. Then I heard a voice, and now there was no mistaking the course of events. " Time, gentlemen, please !" Soon all the lights went out and the place was in darkness. A small group of men were outside and I could hear their departing remarks—"Good-night, Bill !" " Good-night, Joe !" I made my way home, puzzled at the turn of events. All of a sudden I realised my mistake. It was Sunday, and they close at 11 p.m. I was sorry, because the exposure had been only half what I intended to give. Great was my surprise, however, when it turned out quite all right, for it has since been reproduced in several papers.

The amateur photographer of those days was not keen on taking up this branch of photography, and only an occasional one appeared at intervals at the Salon or the Royal. My idea in making that set of slides was not only to create a new departure, but to kill the idea at the same time, for my set numbered 18, and represented nearly all the most promising subjects. After the Great War the idea cropped up again, and was put forward as something quite new until a firm who sold a great number of these slides wrote about it. Now it has become quite a regular thing for clubs to have annual competitions relating to night photography. With the advent of very fast plates and very fast lenses and the brilliance of present-day illuminations it is possible to take snaps at night which have a life in them which mine lacked. On the other hand, when I have shown my slides at some of the clubs members have expressed a preference for mine. There is something about them that they like, but cannot quite define. Perhaps it is the

quiet serenity of evening which is lacking in the present-day night pictures. I must say I should not care to do any under the present-day conditions, the streets jammed with traffic, neon lights everywhere, and with the panchromatic film recording all the colours making matters worse. I saw a reproduction of the Alhambra at night, before it became the Odeon, and it was simply a piece of black paper upon which one could read right across in neon lights the name of the film being shown, with various ornamentations. In different colours these, no doubt, were very effective, but rendered in black and white they simply appeared as streaks of light with lettering. The only clue as to what the place was, was the word Alhambra in small shame-faced letters at the top; there was not a sign of the outline of the building anywhere. In fact, the whole front was covered up, and one was thankful that the trees practically blocked out the view.

On the other hand, I have seen many pictures taken at night, principally of squares, that are perfect, especially where there is flood lighting. But, when the exposure is ample and there is plenty of detail in the shadows, one can easily mistake them for daylight pictures, and the present idea of turning night into day seems on the point of being fulfilled. A few years ago I was spending my holiday in a small Swiss village, tucked away in the Alps, called Saas-Fee. It has five large hotels and is a great centre for mountain climbing, though if you want to get there you have to walk for four or five hours unless you hire a mule. In the hotel where I stayed there was an enthusiastic amateur photographer, and one evening after dinner I said I would show him an enchanting subject. He brought along his camera and I took him a little way out of the village and told him that if he would wait a few minutes he would have a fine view of Saas-Fee by night. All the hotels were already lit up and many of the chalets as well. It was really a delightful picture, but from the photographic point of view there was one fly in the ointment: the sun had set at the back of the picture, rendering the twilight a little too assertive. To do it justice a panchromatic plate with a red screen would have put matters right, but he had only an ordinary film, so exposed it, giving the subject barely five minutes at F.11. He sent it to be developed by the local firm, and when it came

back I could see by his pleased expression that he was delighted with it. " It's topping," he exclaimed and handed it to me. I could not respond, I was absolutely astonished; it was a perfect daylight picture. The man, not understanding it, had considerably over-developed it and then printed it on the most contrasting paper he had. The result showed the deep blue twilight sky as nearly white, killing the entire picture. But he was pleased with it, so I did not comment any further.

I have mentioned that two principal exhibition societies, representing the official photographic sentiment of the day, were not encouraging towards the type of subject which I was then taking. There was more outlet in the suburban clubs, but even there many members regarded some of my studies as rather *infra dig.* or even shocking. They felt that a plate demanded a noble and dignified subject, a cathedral or mountain or family party dressed up in their Sunday best. Few envisaged the popular snapshot until the coming of the hand camera and the Kodak.

IV

KODAK SNAPS

M Y introduction to Eastman's Kodak firm was entirely due to Mr. George Davison, the Vice-President of the West Surrey Photographic Society. He was one of the finest pictorial photographers of the day, and it was due to his influence that the Camera Club was first started. He formed the club just before the split with the Royal, owing to the rejection of his famous pin-hole photograph, " The Onion Field," and before long he, with several supporters from the Camera Club and a few from the Continent, started a show of their own called the Salon, under the auspices of the Linked Ring. Mr. George Davison was at that time secretary of the Camera Club, and it was, no doubt, in this capacity that he met Mr. Eastman of Kodak fame.

Mr. Eastman had just come over from America to ascertain why it was that the business of Messrs. Kodak was not progressing as fast as he would have liked. Although I was always on very good terms with Mr. Davison, I do not know what happened just then, but Mr. Davison resigned his post in the Civil Service, and took over the European management of Messrs. Kodak. Soon I got a letter from him making an appointment for me to meet him at Messrs. Kodak's head office in Clerkenwell Road. Wood-engraving was by then on its last legs and he wanted me to join the Kodak firm, but I had learnt that the prospects of the Kodak film were none too rosy, so I politely declined.

Then he said that he wanted me in my spare time to do something for him in the photographic way. He wanted me to go and take some of my street " snaps " with a Kodak. I could have whichever camera I chose, and he would send me fresh films as required. I was to return them quickly, as soon as they were exposed. " Don't delay," he said, " although you may have one or two unexposed."

This seemed to me like overripe fruit that will not keep.

However, I exposed the first roll and returned the spool, using a Kodak Falcon No. 2. The prints were duly sent to me together with a letter from Mr. Davison asking me to come and see him. When I went I told him that I was not in the least impressed with the result of the Falcon No. 2 compared with the results from my " Facile "; the film was far too slow and the shutter too fast. He told me that he would have the slowness of the film remedied and the shutter slowed down. The result was that the next lot were only a little better than the first, so he changed the camera.

I, on my part, gave up City exposures and shifted my ground to outer London. The camera I had then was a ½-plate one, one of their very best, and I decided to try Victoria Park. These turned out much better, and some were quite good. My next effort was Hampstead Heath on the Bank Holiday. This I considered would give me some " Cockney snaps," which it did, but they were still not up to the results that I had had from my " Facile."

I received two prints from each film and also the films of which they would not be making any further use. I was not the only one engaged in making exposures for Messrs. Kodak, for, as Mr. Davison was in touch with all the leading pictorial photographers of that time, he got several to do the same thing that I was doing. He thus obtained some very good examples of Kodak snaps. Some very good enlargements of them were made, and they were exhibited in one of the leading galleries. The entrance was free, and the slogan was " Come in and see what can be done with a ' Kodak.' "

The success was immediate, and Mr. Davison wrote to me and told me that the results were " prodigious," and asked me to reconsider my decision about joining him. I told him that I had nearly completed arrangements to start with my future partner, Mr. H. G. Dorrett, and he never bore me any malice for my refusal to do as he wished. On the contrary, he sent me each year a Christmas token in the shape of some of his best work executed in photogravure by Craig Arman of Glasgow. These I have now given to the Royal Photographic Society.

From then onwards Kodaks came to stay and became a striking feature of amateur photography. By judicious publicity they captivated millions with the words " You press the

button and we do the rest." Eventually it became possible to obtain a small Kodak by just saving the coupons given away with certain brands of cigarettes, but others followed suit and, competition getting keen, they combined to stop it. Celluloid films coated with a sensitive emulsion date a good way back, for Parker took out a patent for a transparent celluloid support for sensitive coating in 1856, Hyatt of the U.S.A. made celluloid in 1869, and in 1884 emulsion-coated celluloid was made by Carbutt of Philadelphia. It was Mr. Eastman, however, who in 1888 came out with the roll film camera which he called Kodak, supplied with stripping film. When he put this on the market he wanted a simple name that would catch the public eye, and Kodak seemed to fulfil his requirements, but he was not the inventor of the film which caused the success of the Kodak, and in connection with the patent he had later to pay considerable damages to the original inventor.

One improvement followed another. In 1889 Mr. Eastman put his transparent roll film on to the market, in 1891 he introduced the daylight loading, and in 1902 he introduced daylight development of roll film by the rotating system. By then Mr. Eastman had turned his business into a company known as Eastman and Co., with branches all over the world. The business of Messrs. Kodak went on expanding and does not look like stopping.

The non-curling film was not introduced till 1903, and this was a great boon to all workers, amateur and professional. Only those who have worked the original films know what a trouble they could be when dry. Mr. Davison kept only the few films that he required for his publicity campaign, and I kept all the films that he sent back to me for some time under pressure, but when I went to examine them they all behaved like watch-springs. And worse was to come, for a few years afterwards I had another look at them, and they were not only full of kick, but had become discoloured, no doubt from improper fixing. I still have a few of the better-behaved ones, but they are mostly very much under-exposed, although I gave them the maximum exposure I could. On the other hand, the Solio prints which were supplied to me at the same time are as good now as the day they were produced. They

are now just forty years old, and during my professional career I have never had to find fault with any of their products. We may sometimes have placed orders with other firms, but that was on account of prices, as we had to cut things very fine.

Not so very long ago in reading my daily paper there was an article concerning someone who, on account of illness and under doctor's orders, had to be removed to the Riviera. For this purpose it was necessary to have a special carriage put on the train from the coast to Nice; the estimated cost was, I believe, to be £200. I did not notice the name particularly, but read in the paper a few days afterwards that he had passed away only a day or two after his arrival. They mentioned that it was a Mr. George Davison, late general manager of Messrs. Kodak, and in the *British Journal of Photography* I also read his obituary. They recalled the circumstances of his resignation, and they also gave a copy of the letter sent to him from Mr. Eastman which brought about his resignation. It appears that he had turned " Red," and it came as quite a shock to me, as I knew him to be just the opposite a few years previously. They stated that he was a wealthy man and did a lot of good. It appears that anyone with any new idea, cranky or otherwise, could get a hearing from him, if not financial assistance. On the Riviera, I was informed, he looked after a large number of children and defrayed their keep and education.

Soon after the early exhibition of Kodak snaps that I mentioned, I happened to be passing down Cheapside and, noticing a large crowd of people looking into a window opposite, I went across to see what it was all about. To my great surprise it was a big enlargement of one of my Hampstead Heath snaps, one in which the girls are all dancing. Such a thing had never before been seen, and the comments were very entertaining and amusing. Some time afterwards I was talking to one of their travellers and told him about the Cheapside incident. " You know what happened ?" he said. " The police told them they were creating an obstruction, so they had to take it in." I often think of this obstruction that my photographs created, but still more of the good offer to join the Kodak firm that I turned down. They say that a chance comes only once in a lifetime, and I believe it now !

V

PRESS WORK

THE first big national event that occurred in our professional career was the funeral of Queen Victoria on February 1, 1901. We accordingly decided to get photographs of it if possible. After considerable trouble we managed to get all the necessary passes that are required on these occasions. We were allocated to the Hyde Park Corner area, on the side of Apsley House. The procession would enter Hyde Park by the central arch and proceed to the Marble Arch. All the photographers had to report by 7 a.m., and then we would be given our places, although the procession was not due till 11.30 a.m.

The morning was cold and very dull, making the prospects very doubtful. About 8 a.m. one of the Park officials came up and asked if anyone cared to go up to the top of the arch. Every hand went up, so he said, " I will have a ladder brought up." Eventually the ladder did arrive, somewhat late owing to the vast crowds surging into the Park. It was duly placed against the central arch, but, to the consternation of all the photographers, it did not reach to the top, only as far as the cornice, necessitating some acrobatics to get safely to the top. Everyone declined except my partner, who told me to fasten the camera on his back and he would risk it. This provided some *divertissement* to the crowd, who were by this time perishing with the cold. Well, he managed it all right, so that now he would have only three hours to wait before the procession came along. My position was between two of the pillars at the base, commanding a good view of the route, which by this time was being lined by troops, police and reserved places for the boys of the Greenwich Naval School. We were probably about one dozen photographers all told, but only one pressman; the others had all kinds of large cameras on stands, suitable for the occasion. The pressman next to

me was on behalf of the *Sporting and Dramatic News*, a Mr. Archer I believe. I had my old friend the " Facile," and as it turned out it was also its funeral.

It was not long before the Park was absolutely packed, and looking in the direction of the Achilles statue it simply looked like one huge mass of faces. The trees all round soon became well occupied, in spite of the police telling the crowd to come down, which they did; they soon went up again. The police did not disturb them any more, for the simple reason that they were unable or unwilling to push through that solid crowd. The poor beggars were well rewarded, for the weather became perishingly cold and damp.

After what seemed to me three weeks, the procession at last came along. I did not look at my watch, as I was too cold to unbutton my coat, but I could hear the Chopin's Funeral March. It was played over and over again till I knew it off by heart. Then the guns in St. James's Park joined in. At long last the procession was coming through the arch; off came our hats and click went the shutters of the cameras. I have a faint recollection of seeing a Union Jack which covered the coffin, also the Kaiser on a white horse. My camera saw it all, but I had to wait until it could transfer to me the beauty and the solemnity of the occasion. You naturally like to take as many as you can, so that your entire attention is centred on your job and you miss the pageant. Seeing the impressive scene on your dull view-finder of the size of a stamp does not fling you into a state of uncontrolled ecstasy or reverence.

I could not see my partner, but he obtained quite good results, as being higher up he had a good view. Soon after the procession had passed the crowd surged and pushed so hard that they broke through the lines of military, police, etc. That vast open space became a solid block of human beings, all pushing in different directions, thereby nobody making any progress. My partner could see it all with interest and dismay, for the question arose, " When will they be able to get that ladder along, with all this crowd ? Everything comes to him who waits. He only had to wait till 3.30 p.m. (same day).

As soon as we got the plates developed and proofs struck off we approached the print sellers for orders, being the best market then for such things. We had not far to go, as near our

VICTORIAN SNAPSHOTS

Strand studio was Messrs. Deighton and Son, near the Grand Hotel. Their representative came at once to make arrangements with us to supply him with a quantity as soon as possible. He wanted 12 by 10 prints, whereas my partner's negatives were 8½ by 6½ and mine 4¼ by 3¼. Consequently enlargements had to be made. Fortunately there was a brand of Kodak bromide paper just put on the market that yielded better results than previously. Our great handicap now was that we had only one artificial light enlarger and one daylight. The latter we ruled out as it was winter-time. We had twenty-four negatives altogether, and only one print can be enlarged at a time. Every minute being precious and the demand being great, we had to work well into the nights to obtain a fair supply. As it turned out we were the only ones to get decent results of the procession in Hyde Park, owing to the weather being so unfavourable. The pressure becoming too great, we decided to make enlarged negatives and send them to a firm in the north of London who specialised in quantity work.

For some unfortunate reason they kept us waiting much longer than the time promised. This brought about a crop of complaints from the dealers. At last a batch was delivered, but to our horror they were much below the standard of work we had been supplying. Nevertheless, we sent them in, and every one came back with notes to the effect that unless we could supply them to the standard of the previous deliveries the orders would be cancelled. So we resumed on the previous method, but by this time the demand had slackened. During the rush a representative of Messrs. Cassell and Co. came to see us with reference to reproducing one in their publication respecting Queen Victoria. We argued that as soon as that appeared sales would suffer accordingly. So we asked £10 for permission to reproduce. " Preposterous !" was his remark. " Very well, find another firm," we said, for we knew there were no others on the market. As he left he said, " There are many more on the market." Next morning came a letter saying, " Please send on prints," etc.

After our experience of Queen Victoria's funeral we naturally took a chance for the coronation of King Edward VII. I

had then designed a new kind of ½-plate camera for this sort of work, after the style of something I had seen at a sale, which contained many faults; the idea was of the image projected on to the plate being reflected upwards on to a screen up to the time of exposure. They are now on the market, and called " reflex cameras."

The Press at this time were using more photographs for their illustrations, and process was also extensively used for their reproduction. One might say that the death of Queen Victoria was also the death of wood-engraving as the principal method of reproduction. Photography was so much quicker and cheaper. At first they required only glossy silver prints, a slow process. These were contact prints made in daylight. It was evident that under these circumstances it was necessary to get your subject on the plate as large as possible. The idea of taking a ¼-inch square from a negative and enlarging it to 24 by 20 was unknown then, besides being unsatisfactory, as the fast plates were very grainy and would not stand the enlarging to that extent. Consequently I had that camera made to take, besides the ½-plate lens, one that we used for 12 by 10 work. It was a Zeiss combination of various focal lengths, this necessitating an extension of the bellows to 18 inches and more. The camera held eighteen ½-plates in sheaths, enclosed in a changing bag at the back. The shutter was a focal plane one, and made to work at anything from half a second to one-five-hundredth of a second. It is with this camera that I took photographs of all the events during coronation year.

For the coronation procession it was necessary to buy accommodation at a suitable window. The Press want the best view, and to get the vest view-point you had to pay accordingly. We found such a spot over the post office in Pall Mall, overlooking Marlborough House and St. James's Palace. The day turned out fine, with the result that competition was very keen, so we did not clear our expenses.

I next turned my attention to the many events that took place during that summer, so that things turned out satisfactory in the end. It is something of a task running around to submit prints to the various papers, who were then favourable to using photographs. A firm started of the name of

Bolak who did this kind of service, both in London and abroad, so we took advantage of it.

The Boer War had come to an end, and the troops were returning to headquarters. In due course came the presentation of medals. This took place on the Horse Guards Parade. Then came a review of the troops that had been engaged, including the Indian and Colonial. These also took part in the coronation procession.

Everywhere the place was lavishly decorated for the occasion, but one item stood out from all the others. It was a triumphal arch erected in Whitehall by the Canadian Government. It was entirely covered in sheaves of corn, and at night it was a blaze of electric lights, this being the first time such a display was seen. Needless to say, all London flocked to see it. No " neon " lights then ! I secured a night view of it, as well as a daylight view. The extension to the Abbey was also a feature. It was called the Robing Room, and it was so well executed that it was indistinguishable from the structure of the Abbey itself. The same was done for King George VI.

One of the first acts of King Edward VII. was to attend the Opening of Parliament in State. This ceremony had been allowed to lapse by Queen Victoria. We took this from the balcony of the House of Lords entrance. The King also visited Ascot with Queen Alexandra on the Cup day. I noticed that the crowds were allowed to stroll on to the course before the races. There were no car parks then, but a place was reserved for the four-in-hand coaches, which turned up in full force.

The Boys' Brigade also had a review on the Horse Guards Parade, when unfortunately the weather was wet. The same thing happened at the Trooping of the Colour, attended by the King and Prince of Wales. President Loubet came over with his full complement of ministers, etc., and was met by the King on his arrival at Victoria.

Queen Alexandra on her side entertained over 2,000 orphans at Marlborough House. Every kind of conveyance had to be obtained to convey such an enthusiastic crowd. It was amusing to see the girls climbing up the short ladders so as to reach their seats on the wagonettes, etc. A Life-Saving

Coronation Gala was held at Hendon, and one of the interested spectators in a row-boat was Mr. Asquith, not then in office.

I think one of the most imposing displays was the review of the Indian and Colonial troops on the Horse Guards Parade. It was attended by all the foreign military attachés, headed by Lord Roberts. Queen Alexandra was there with Princess May (Queen Mary) and Princess Maud. One little boy who was very interested in all this display was at one of the windows overlooking the Horse Guards Parade. At his side was Prince George of Greece. As this little boy was looking around at the scene, his eyes fell on my camera, and mistaking it for some new kind of machine-gun, he immediately " ducked " and disappeared. Prince George, however, soon brought him back, and made him face the camera, which he did. I raised my hat and made the next exposure. That is how I came to take a photograph of Prince " Eddie," aged seven, who in turn became Prince of Wales, King Edward VIII., and Duke of Windsor.

Queen Alexandra when she first saw my camera was not a bit frightened, as she was an ardent amateur photographer herself. She may have remarked to herself, " My, what a camera !" but she just smiled.

One of the minor events of the year was the completion of the Westminster Town Hall in Charing Cross Road. This was duly opened by the Duke of Cambridge, who afterwards inspected the Guard of Honour assembled. He was also responsible for the unveiling of General Gordon's statue close by. Afterwards this statue was sent to Khartoum, the space now being occupied by Nurse Cavell's memorial. General Trotter and General Kitchener duly assisted at the unveiling of Gordon's statue. The latter was in mufti, and was the cynosure of all the surrounding female eyes. The Duke of Cambridge at this time was feeling the effects of his advancing age, so his son, Colonel FitzGeorge, helped him to get back into his carriage.

Trafalgar Day was also celebrated in keeping with the auspicious events of the year. At the Earl's Court Exhibition a special charity bazaar was held, also to celebrate the event. The Alhambra put on a special show, and we were asked to try to take it by artificial light. There being at that time

only magnesium powder, we tried that in a special lamp with success at one of the rehearsals. Flashlight work was then in its infancy, and the lamp we used was one of the first to appear on the market. It was on a telescopic stand which could be fixed on the back of a chair, and so could be raised to a convenient height. The magnesium powder was sprinkled along a narrow tray on some guncotton, so as to ensure rapid combustion. It was fired by means of a safety match that was fixed in a trigger that made contact with the match-box, in the usual method of striking those matches. As it bursts into flame it comes in contact with the guncotton, which ignites instantly with the flash-powder. A rapid, vivid flash is the result, and the exposure is made, the lens being uncapped just previously. The flash is somewhat startling and plenty of smoke ensues. It was crude, but it was then the only means of taking flashlight groups, etc. Now the same result is obtained by the flashlight being ignited by electric contact in an electric bulb—no noise, *no smoke.*

Princess Christian was asked by the Religious Tract Society to preside at a special meeting at Exeter Hall in the Strand, and accept the presentation of purses which were for charitable purposes. We were approached as to whether it would be possible to take it by flashlight. We risked it and turned up, fixed up the lamp and all was ready. We were up in the gallery and had a commanding view of the ceremony. It only remained for us to select the appropriate moment to make the exposure. At the arranged signal my partner uncapped the lens, whilst I pulled the string of the flash-lamp. A flash! an explosion! and a white balloon floated to the ceiling. The lamp was recharged and a fresh plate got ready, when the Chairman shouted: " I should like to tell the photographers that Her Royal Highness does not object to being photographed, but she does object to being frightened out of her life, so please, if you are taking any more, kindly put up your hands as a warning."

As it happened we were ready for another exposure, and I immediately put up both hands and pulled the string once more. This time the explosion seemed louder than before, and the flash more vivid—no doubt on account of being warmed up to it. Another white balloon made for the ceiling,

where the other one had been, but was now descending into the audience in the shape of a white fog. We did not wait to hear what the Chairman had to say this time, but we snatched up our camera, lamp, etc., and vanished from the building. We ran down the Strand till we arrived at a convenient alley, where we repacked our gear, camera, etc., and went home.

The photo turned out all right, but the proceedings had to be suspended, so we were told, until the smoke had disappeared.

By this time the illustrated papers were using more and more process, so that one might safely say that as the curtain went down on the life of Queen Victoria the curtain also went down on wood-engraving.

Even then there were but very few papers that recorded passing events in pictures. Process being cheaper than wood-engraving, they saw the future possibilities, and they accordingly employed a photographer as part of their staff. This made the lot of the free-lance man more difficult, as naturally they used his prints first as they defray the cost; besides, he has his pass to help him. They also realised that the printing of contact prints on P.O.P. by daylight retarded production, so they reluctantly accepted bromide prints for the purpose.

The makers of bromide papers soon turned their attention to placing on the market suitable papers, as, what is more important, the prints can now be made by enlargement. This means that a smaller plate can now be used and the essential part only enlarged. Firms are now producing no less than six different grades of paper for this purpose.

Fortunately for us we became very busy in another direction of our business, necessitating giving up Press work. It is pleasant, however, to know that once more we were in at the beginning.

LIFE IN TOWN

LIFE IN TOWN

IN comparing any set of street photographs of fifty years ago with a similar set of to-day we are struck with two thoughts, seemingly somewhat contradictory. The first is suggested by the evident changes which have taken place, and the second is that, in spite of such changes, the Londoner or any big city dweller is essentially very much the same in character.

The apparent leisureliness of London or Paris of the last century is of course only relative. New Yorkers affect to find us leisurely in England. No doubt our transport will seem very slow to our grandchildren. There was this about horse-transport: that it was not so fast, as compared with humanity's own step, that a man could not walk about the streets without risking his life. Traffic blocks were beginning to affect the circulation of the traffic in London, so that our governors have had at least half a century in which to replan our streets. London is poorer for the disappearance of many traders, side shows and street markets. Whether the reason is that we have less leisure or that there is less room, it would be difficult to say.

Dress has not changed remarkably. The top-hat and the bowler are no longer so common, while the tail-coat is hardly ever seen to-day except with top-hat. Women's fashions continue to revolve in periodic cycles, so that the lady emerging from the hansom-cab accident would have been almost fashionable with her puff sleeves two or three years ago. The urchin's rags would have been very much the same if taken yesterday.

Singularly little photographic evidence is available to illustrate how the man in the street behaved even fifty years ago, partly because cameras were not quick enough in action, and still more because photographers did not think of wasting precious plates on scenes which seemed to have no particular interest. The usual request, when taking a street scene, was for passers-by to stand clear. We can only wish now that a few more photographers had been as curious-minded as Paul Martin, who carried his detective camera with him, all ready for emergencies, even though it weighed several pounds.

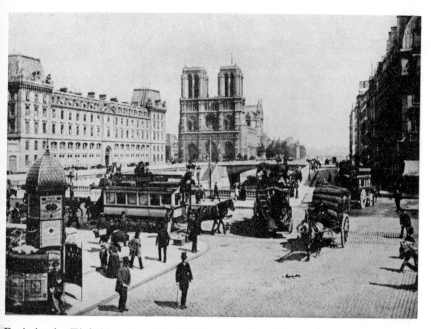

Paris in the Eighties. Pont St. Michel, showing Notre-Dame. [Photo: E.N.A.

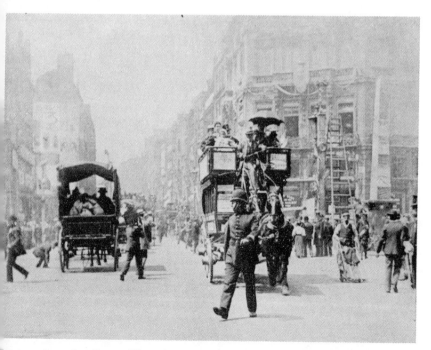

Preparations for Queen Victoria's Diamond Jubilee, 1897.
Decorating at Ludgate Circus.

[Photo: Paul Martin.

I

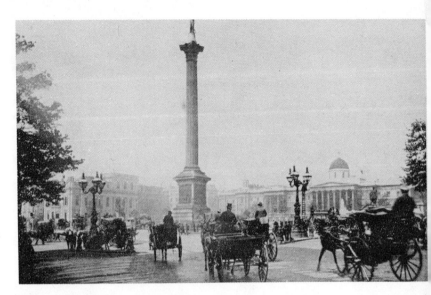

Trafalgar Square in the Nineties.

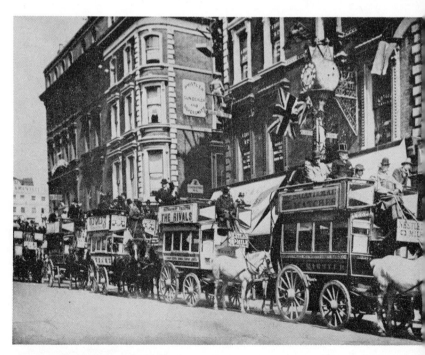

Traffic-jam at Charing Cross.

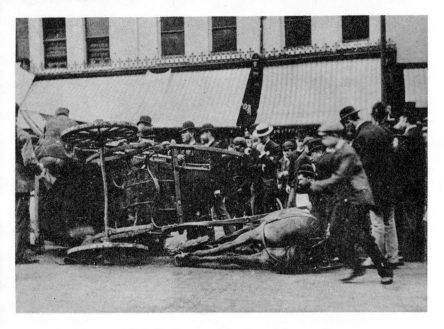

A Cab Accident in High Holborn. The first thing to do in such a case is to sit on the horse's head.

[Photo: Paul Martin.

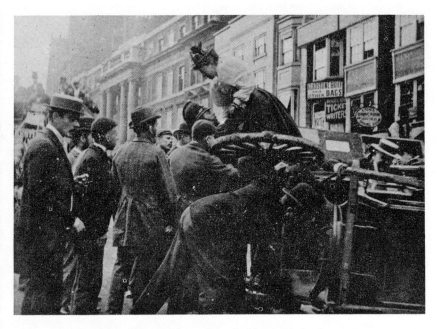

Safe in the Hands of the Police. The bridegroom looks quite pleased about it.

[Photo: Paul Martin.

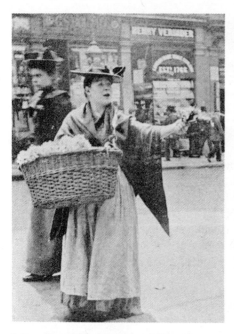

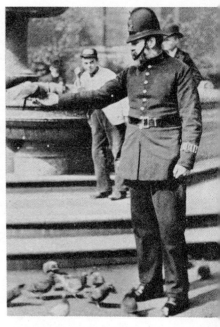

A London Flower Girl. " 'Ere you are, lidy, 1d. a bunch."

A City Policeman, all complete with bea
Taken with plate-stand camera in 1888

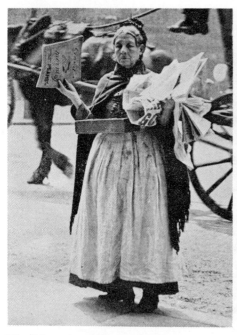

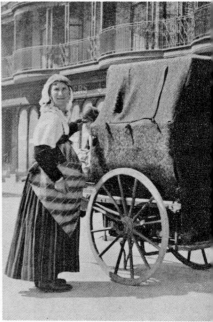

The Magazine Seller in Ludgate Circus. " Tit Bits " was her greatest sale.

The Piano Organ, generally worked
Italians in native costumes. [Photos: Paul Ma

4

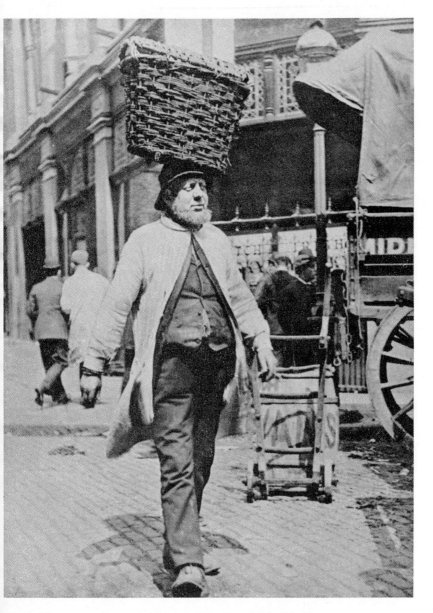

Billingsgate remains unchanged to-day, but is decidedly not so fishy as it used to be. All these snapshots are taken with one of the very first hand-cameras put on the market. It was called "The Facile" owing to its disguise as a paper parcel; it was also known as a "detective" camera. The captions "Facile Snaps" indicate for which pictures it was used.

Photo : Paul Martin.

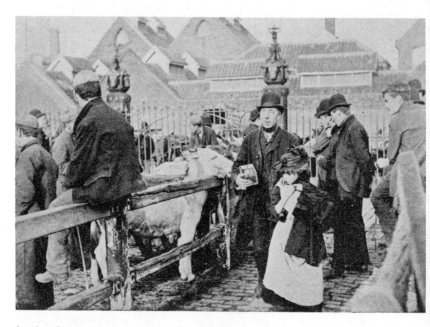

At the Cattle Market, now called the Caledonian Market. [Photo: Paul Martin.

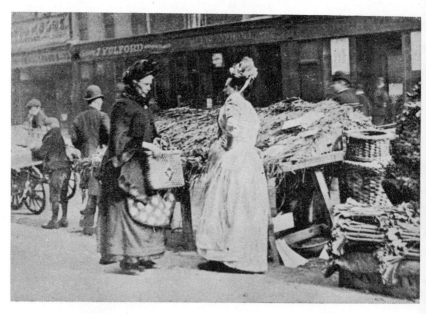

The Street Market in the New Cut. The keeper of the stall has sold all her goods. [Photo: Paul Martin.

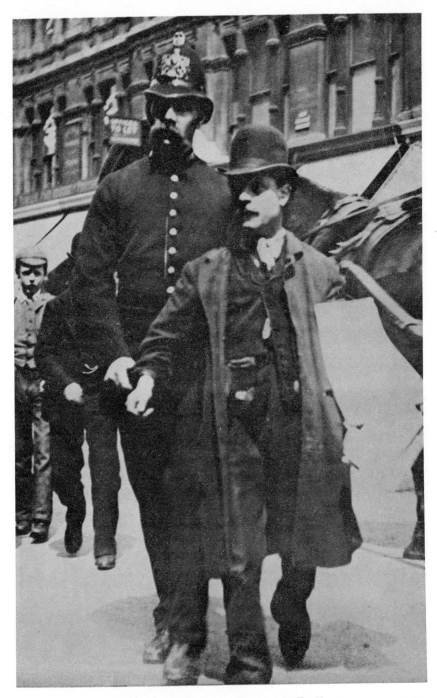

Caught! Off to Bridewell Police Station. A Facile
snap, near Ludgate Hill Station.

[Photo: Paul Martin.

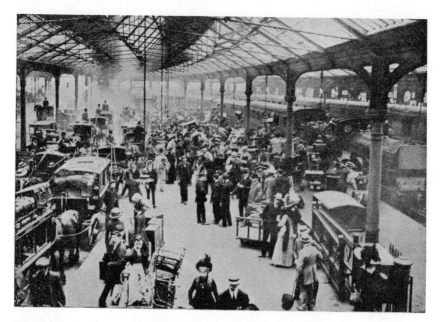

Waterloo Station in the days of the Victorians.

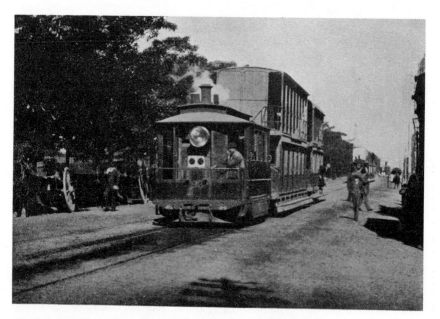

The first Steam Trams in Sydney, New South Wales, about
fifty years ago, moving slowly and ponderously down
Elizabeth Street.

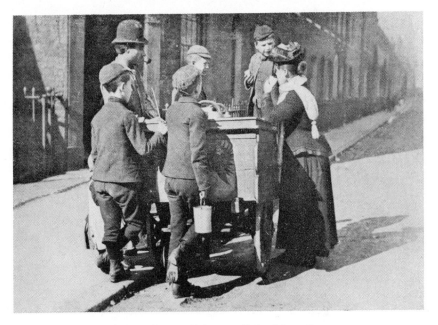

An altercation at an Ice Cream Barrow off the New Cut. Note the old-fashioned beer can, usually carried by errand boys with many others on a broomstick.

[Photo: Paul Martin.

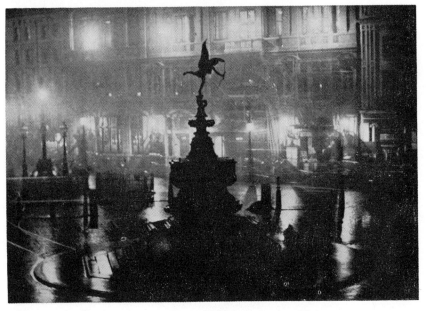

When Eros was first erected in Piccadilly Circus. This photograph had fifteen minutes' exposure, and at the passing of every cab the lens had to be shielded from the candle-lights in the vehicle.

[Photo: Paul Martin.

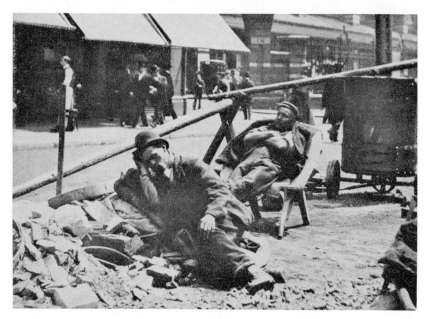

"After dinner rest awhile." A Kodak snap taken in New Bridge Street. In the background is Ludgate Hill Station.

[Photo: Paul Martin.

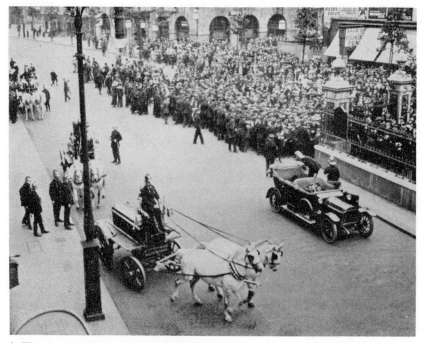

A Fire in the Strand in the Nineties.

[Photo: W. A. Rouch

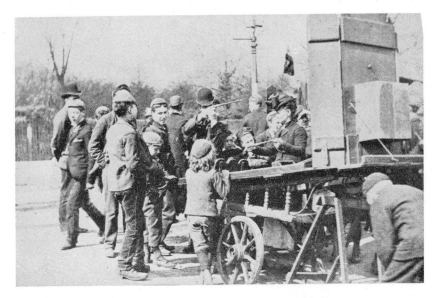

The Fair outside Battersea Park. Here is a youth trying his luck with an air-gun. If he gets a bull's eye he will have some monkey nuts as a prize—and mother's darling wants his hair cut.

[Photo: Paul Martin.

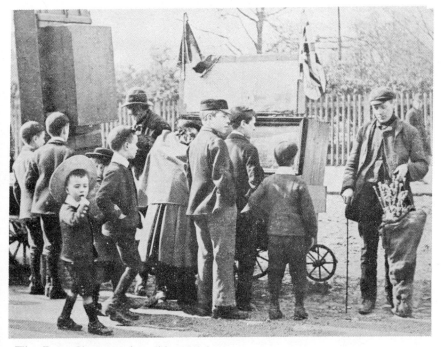

The Peep Show, and walking sticks at a penny a time. These were first attempts with a " Facile " in 1892.

[Photo: Paul Martin.

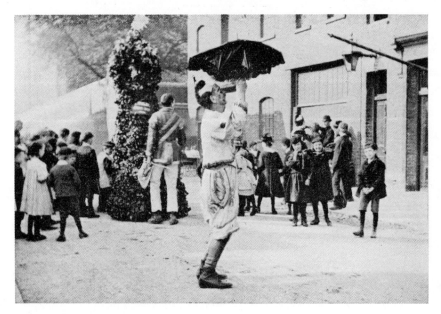

The traditional Jack-in-the-Green organised by sweeps who sing, dance and collect money for charities. Note the barber's pole—it still exists although the surrounding neighbourhood has been greatly changed. Near the Oval Cricket Ground.

[Photo: Paul Martin.

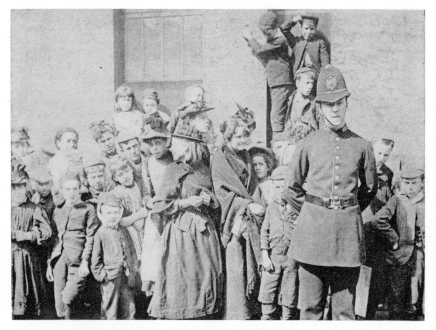

This crowd is waiting to see the funeral of a Policeman who dropped dead whilst arresting a man.

[Photo: Paul Martin.

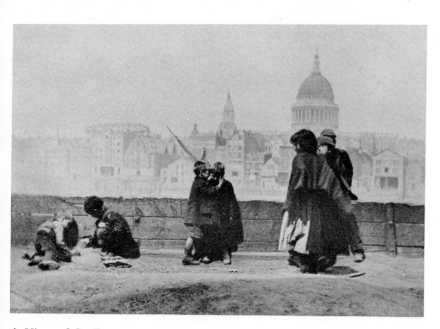

A View of St. Paul's from Bankside, a regular haunt for artists. The skyline has since undergone a tremendous change.

[Photo: Paul Martin.

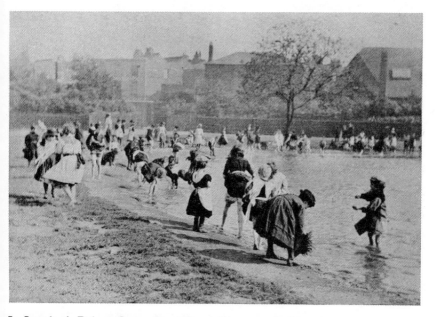

In Lambeth Palace Grounds. The children were allowed to paddle during the hot weather. Tennis courts now occupy the site of the pond.

[Photo: Paul Martin.

13

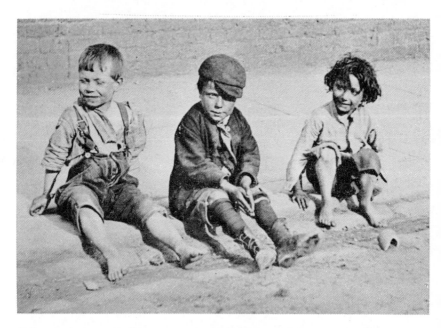

" I called them human squirrels, for when they caught
sight of the school inspector, they were over a six-foot
paling in a flash, and made off to 'Lambeth Walk.' "

[Photo: Paul Martin.

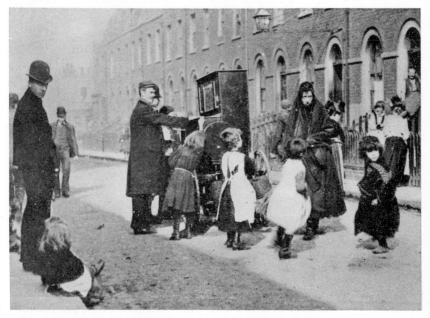

These kiddies are dancing to the *Pas de Quatre*, the
famous Gaiety piece. This entails plenty of leg twisting,
which is restricted by the children's clothes.

[Photo: Paul Martin.

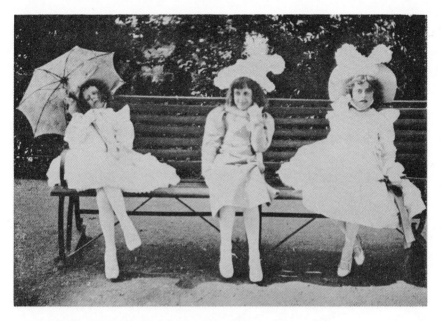

Two Kodak snaps taken in Victoria Park. There they
did love to dress up in white.

[Photo: Paul Martin.

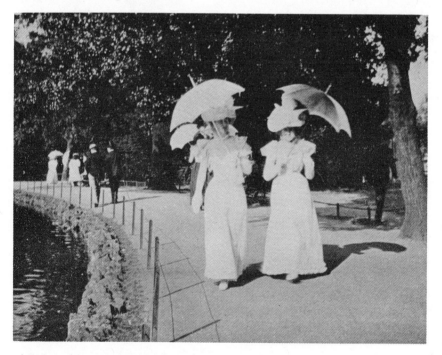

All in white, again mainly for the simple reason that
there was not then the enormous range of materials of
the present day.

[Photo: Paul Martin.

15

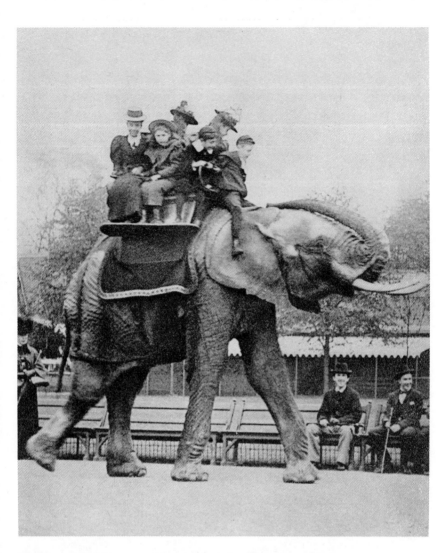

Times and fashions may change, but the pleasures of the people remain more or less the same. At the London Zoo in 1905.

THE COUNTRYSIDE

THE COUNTRYSIDE

PHOTOGRAPHS of life in the English countryside are possibly more interesting for the lack of change they reveal than for contrasts. Both in methods and dress, neither agriculture nor sport has varied considerably in fifty years. Mechanisation is of course steadily affecting the farming scene, but the horse is still rather more common than the tractor, while the structural framework of agriculture has remained the same. So little capital is now invested in the land that it is rare to see a farm building or barn that is not a century or more old.

A few of the photographs depict survivals that could not easily be matched to-day: the ploughing ox, the gleaners, the great parade of smocked beaters, or the netting of wildfowl. The sporting scene has remained very constant, as witness the hunt meets, which might be to-day except that we should see motor-cars in the foreground.

Photographers were fond of going to the country for their subject material, but they saw the countryside through the romantic spectacles of the painters. Hence a vast legacy of twilights and posed leave-takings, but very little everyday hard work or vulgar beer-drinking.

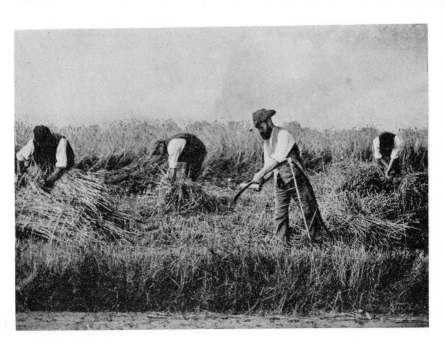

Scything and Binding in 1900. [Photo: *Country Life.*

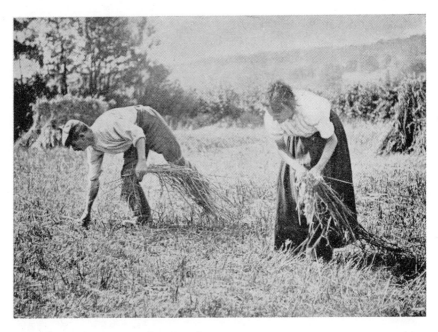

Gleaning. A rare practice even in 1900. Photo: *Country Life.*

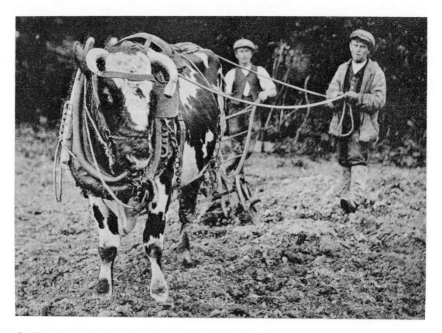

A Shorthorn in the Plough at Hockliffe, Bedfordshire. [Photo: J. T. Newman.

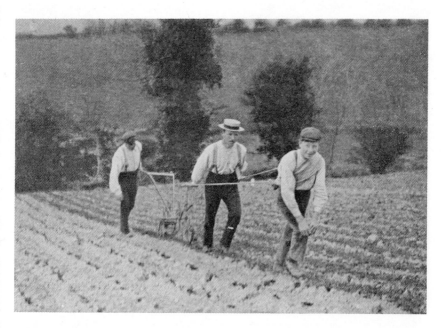

Two Men and a Boy. An agricultural operation about 1900. [Photo: *Country Life.*

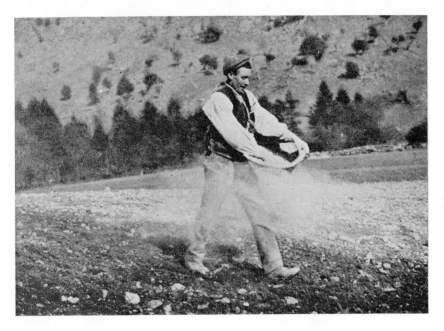

Sowing about 1900. [Photo: *Country Life.*

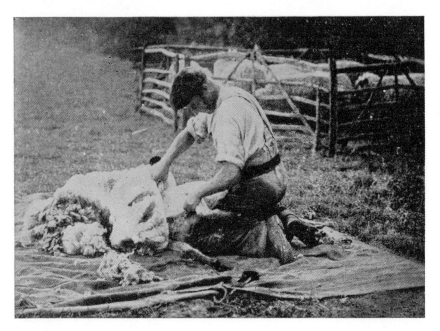

Sheep-shearing about 1900. [Photo: *Country Life.*

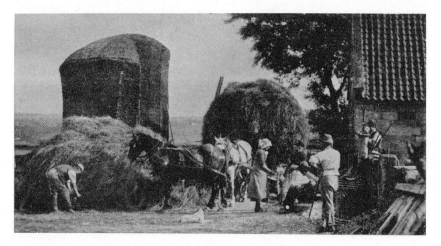

The Ingathering. A harvest scene in the nineties which would be little changed to-day.

Photo: F. M. Sutcliffe.

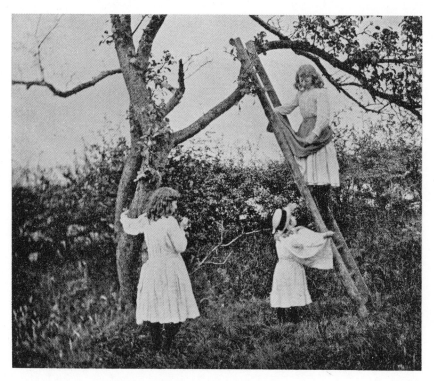

Apple-picking in the Nineties.

Photo: F. M. Sutcliffe.

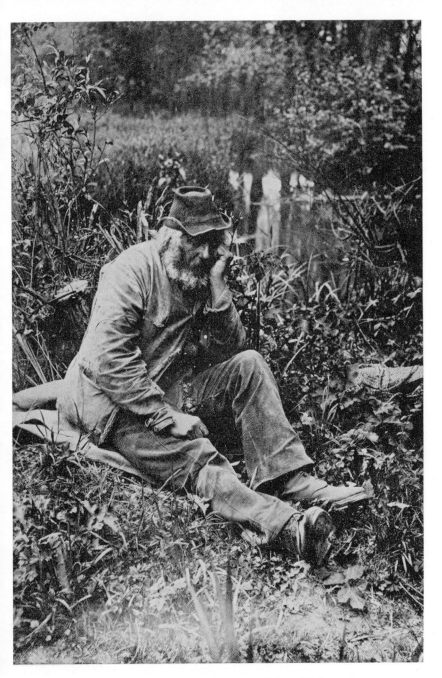

One Bank Holiday in 1889 I was exploring the River Mole
with my whole-plate camera when I came upon this old
tramp. I rigged up my camera and exposed three plates.
He took no notice. I gave him a shilling; but still he
remained silent.

[Photo: Paul Martin

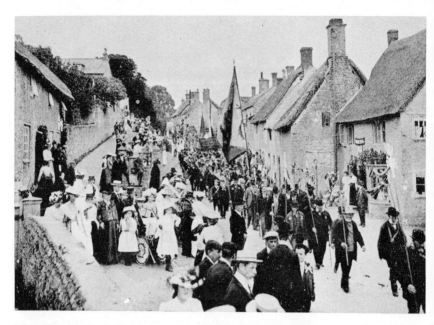

The Annual Club (Friendly Societies) Walk at Stalbridge, Dorset. Fifty years ago.

[Photo: C. R. Stride.

The pride of his native village, James Stevens, the Tring centenarian, in his smock-frock.

[Photo: J. T. Newman.

Hop-pickers at Rye in 1896.

A Gipsy Camp in the Nineties. Little change here.

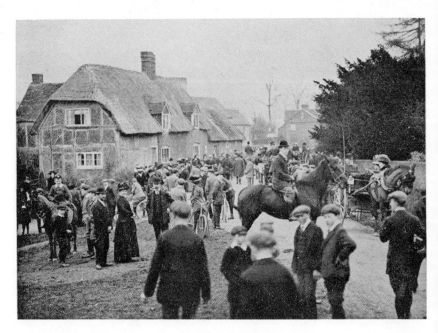

Village Life in 1885. The local Hunt's meet.

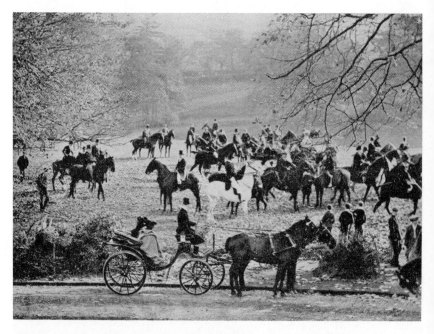

A Meet near Berkhampstead in the Nineties. The chief
change to-day would be motor-cars for the barouche.

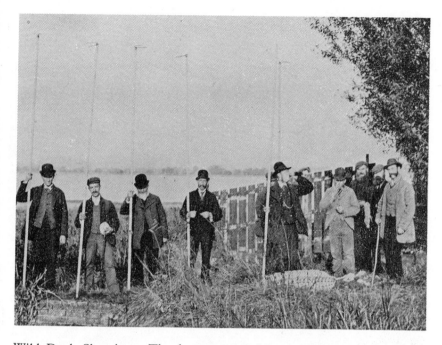

Wild Duck Shooting. The beaters carried long poles, pronged to recover game from the water.

[Photo: J. T. Newman.

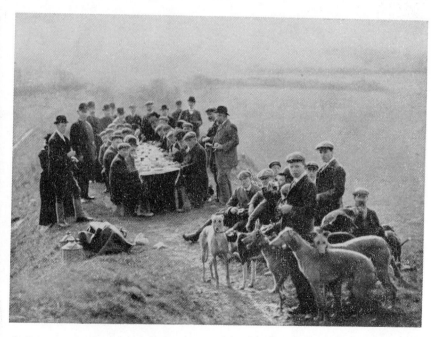

A Coursing Party of Farmers. Lunch in the fields.

[Photo: J. T. Newman.

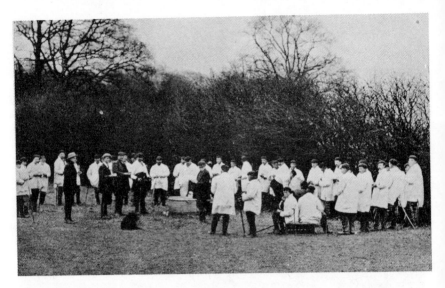

Parade of Beaters for a Shoot in the Nineties. [Photo: J. T. Newman.

Pheasant Shooting. Good sport in the woodlands. [Photo: J. T. Newman.

26

Beating the Bounds: "Running the Gauntlet."
An early snapshot.

[Photo: J. T. Newman.

Out with the Guns in the Eighties.

[Photo: J. T. Newman.

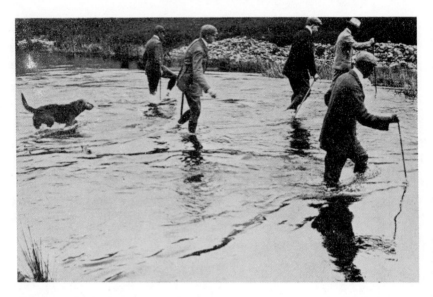

Out with the Otter Hounds. Crossing a stream.

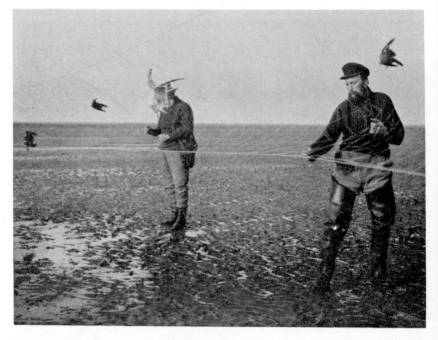

Netting Wild Fowl. A practice now extinct. [Photo: *Country Life.*

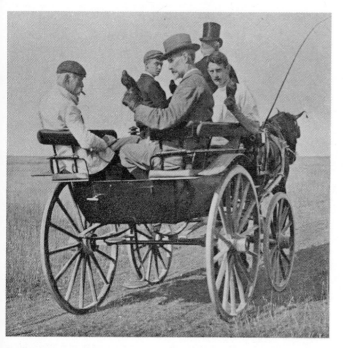

A Hawking Party. About 1900.

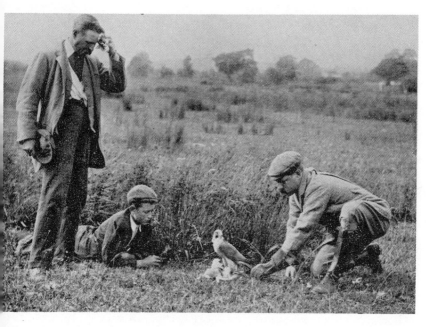

After the Flight. Hawking about 1900.

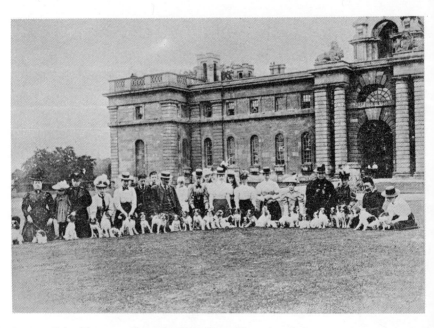

Some of the Entrants for a Ladies' Dog Show in 1898. [Photo: Sport and General.

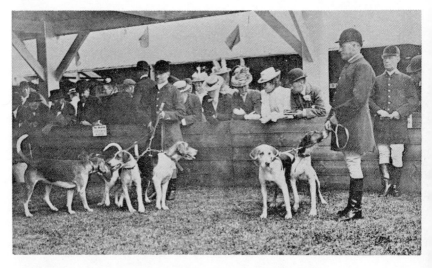

Foxhounds waiting to be Judged at the Peterboro' Show
in 1898. [Photo: Sport and General.

Life in the Nineties. The holiday-makers lend a hand
down on the farm.

Keeping up an Old-time Custom: "A Village Harvest
Home." Dancing on the greensward.

[Photo: J. T. Newman.

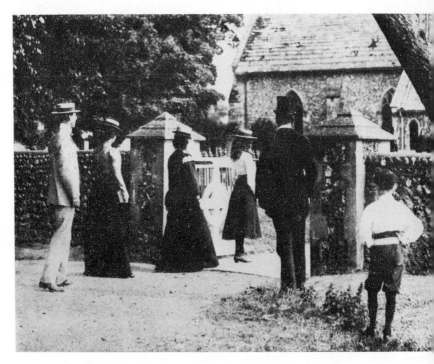

And so to Church. A photographic gem of forty years
ago, near Portsmouth.

[Photo: G.P.A

SOCIETY

SOCIETY

OF what may be termed the amusements of the nineteenth-century society we have fairly ample photographic evidence, especially towards the close of the century when Press photography began to have some commercial importance. Even so, of the real snapshots there is not too much left to-day. There are of course plenty of portrait groups, taken either by amateurs or professionals, and these go back to the beginning of photography, but they have not the same interest to us as the snapshot—the lady at croquet, for example, on page 38, or the racing man which follows.

The events of the London season retain the same atmosphere to an almost incredible degree. For instance, the congratulation scene at Lord's might have been taken this summer. In other scenes the ladies' costume presents a temporary variation, though the gentlemen have remained constant to their conventions. The attitudes and gestures are identical.

Several sports have lost their popularity. Tennis has supplanted croquet in the gardens of country rectories, while archery is probably much less popular. Henley has declined in social importance, though rowing is more widespread as a sport. The houseboats seen on page 36 no longer line the Thames, and since the war Henley has become merely a rowing man's festival.

Cricket Days of Yore—at Lords in the Nineties. The
"fashionable" portion of the crowd at the Eton and
Harrow match.

[Photo: *Topical Press*.

Another View of Lords in the Nineties.

[Photo: *Topical Press*.

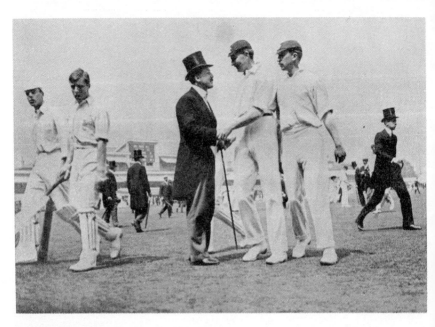

"Congratulations." Lords about 1900.

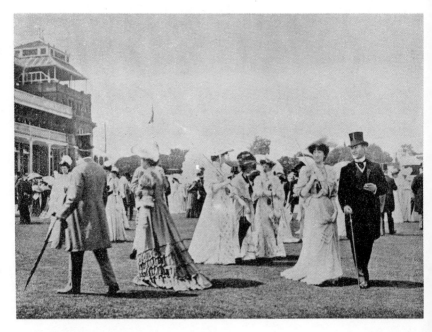

The Promenade at Lords about 1900.

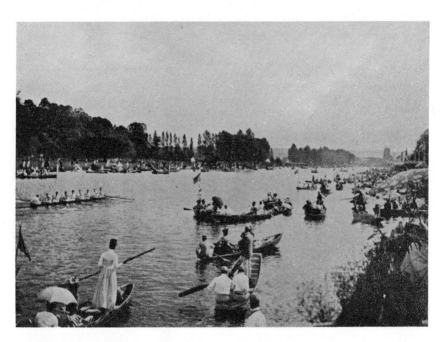

A News Photograph of 1890. A scene at Henley Regatta. [Photo: E.N.A.

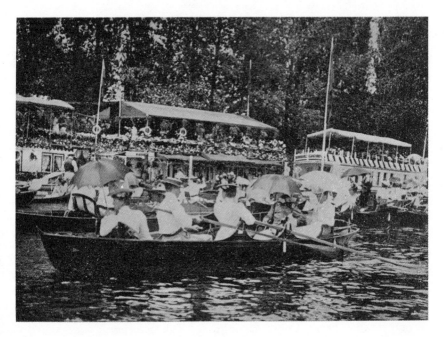

At Henley, about thirty-five years ago. [Photo: W. A. Rouch.

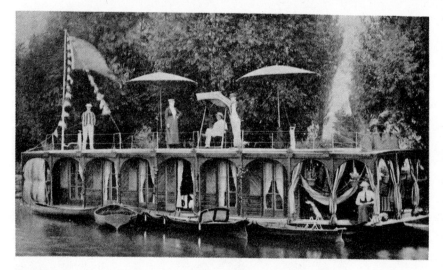

Houseboats on the Thames in 1890. The "Nepoo" at
Shiplake Lock.

[Photo: E.N.A.

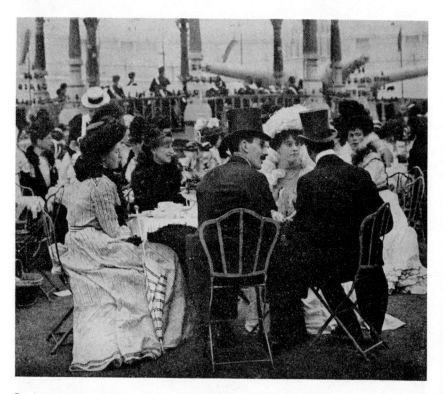

Society at the Earl's Court Exhibition. The occasion
was a Charity Bazaar.

[Photo: Paul Martin.

A Trotting Exhibition at Ranelagh in 1899.

The Coaching Club moving off from Horse Guards
Parade in 1898.

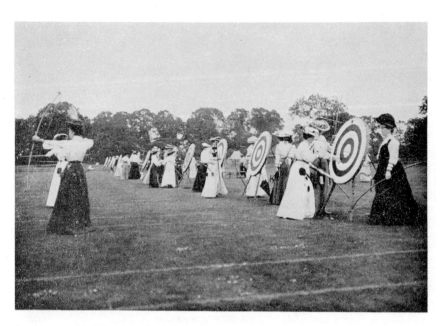

Archery at Beddington Park in 1905.

[Photo: W. A. Rouch.

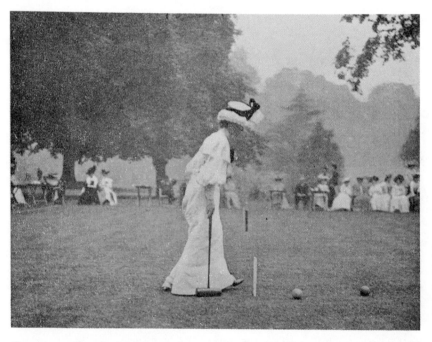

Croquet at Ranelagh in 1904.

[Photo: W. A. Rouch.

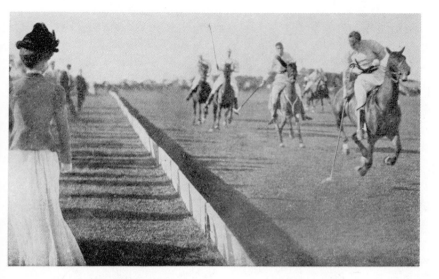

A Polo Match in America.

[Photo: James Burton.

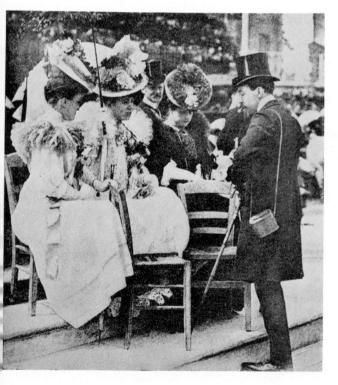

Material for the Gossip Columnist.

[Photo: G.P.A.

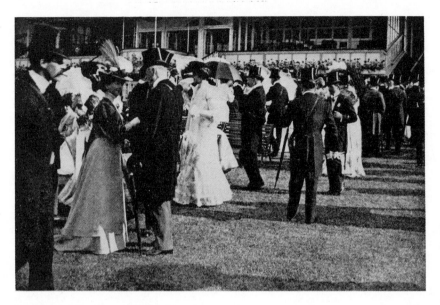

Society at the Races about 1900.

[Photo: G.P.A.

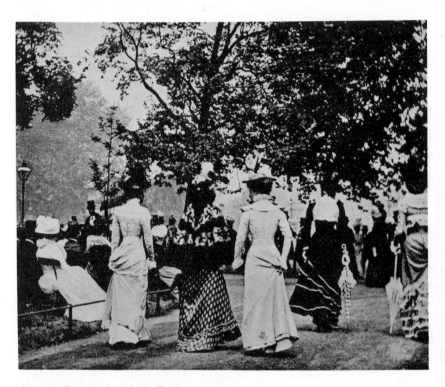

Church Parade in Hyde Park, many years ago.

[Photo: *Topical Press.*

POPULAR PASTIMES

POPULAR PASTIMES

THE end of the century saw the beginnings of those movements which are such obvious features of life to-day: the bicycle exodus to the country for week-ends, the camping life by the river or seaside, cruising for health and amusement, and all the many forms of travel which are now organised as great industries. In those days they were the pursuits of a few pioneers or eccentrics who found their way about without tourist agencies, and very likely enjoyed themselves just as much as we do to-day, though we can so easily travel further afield.

Most popular sports have won acceptance only as the result of a certain amount of brazen courage on the part of early exponents. The lady cyclists with their bloomers were a subject of ridicule and popular ballads, and so no doubt were roller skates.

The musketry of the volunteers carries one back to a time when amateur soldiering was an easy-going affair, mostly concerned with club competitions and occasional inspections by corseted field-marshals.

Of the real popular amusements which were typical of the nineteenth century we have only relics to-day. Hampstead Heath on a Bank Holiday is noisier and more mechanised, but one does not see the spontaneous dancing. The seaside crowd is more interested in bathing than in pierrots. The music halls retain only a foothold as compared with the films. Even the University boatrace is hardly any longer a national event. With the spread of education the amusements of the rich and poor tend to find the same level.

For photographs of the popular life we have to rely largely on Paul Martin's own snapshots, few of his contemporaries caring to waste their plates on the vulgar crowd.

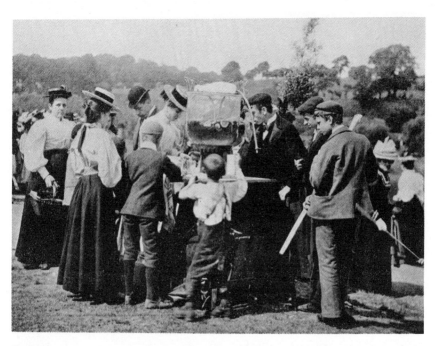

Refreshments. A glass of lemonade livened up with sherbert is welcome. Without the sherbert it would simply be yellow water. Kodak snaps.

[Photo: Paul Martin.

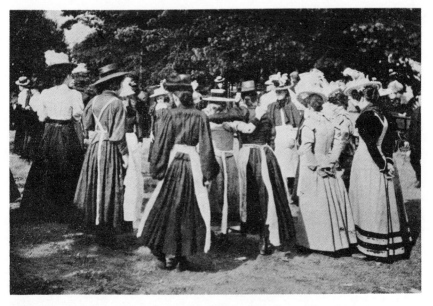

Hampstead Heath on a Bank Holiday offered a great variety of subjects. A group of girls about to start dancing. A mouth organ supplied the music.

[Photo: Paul Martin.

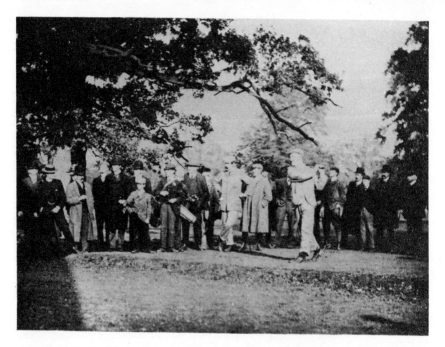

A Scene at the West Herts Golf Tournament. The start
of the Foursomes, J. H. Taylor is driving. Braid, the
champion, is in the centre of the picture.

[Photo: J. T. Newman.

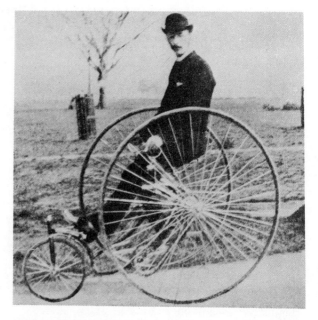

A New Type of Tricycle. The first of its kind to
appear in London. This was in 1885. [Photo: Paul Martin.

In the days of Bloomers. Cyclists on the Quay
at Boulogne in 1897. [Photo: Paul Martin.

The Pleasures of Motoring. [Photo: G.P.A.

Bisley in 1898.

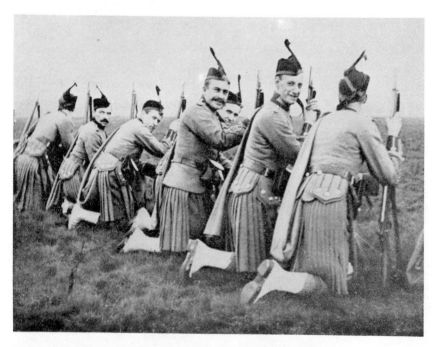

Wimbledon Common was always a noted drilling ground for Volunteers. Here are the London Scottish awaiting orders to charge.

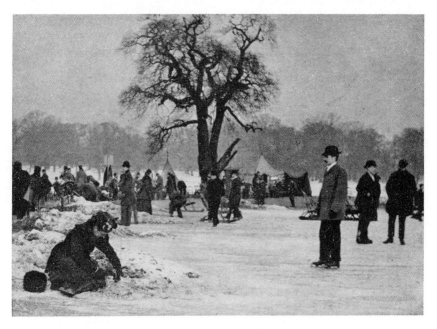

The Penn Pond in Richmond Park during the Great Frost
of 1895.

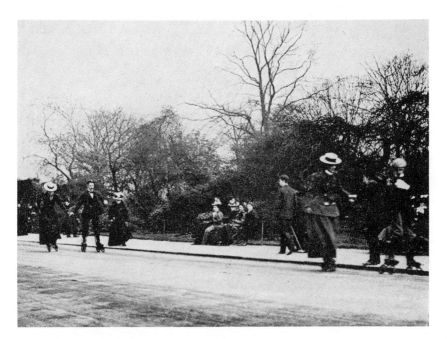

Road Skating in 1898.

[Photo: Sport and General.

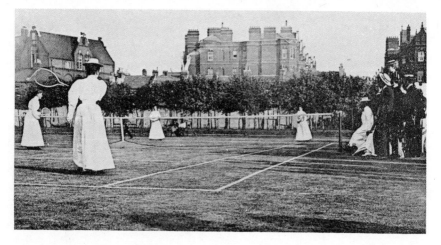

Lawn Tennis at the Queen's Club in 1898.

[Photo: Sport and General.

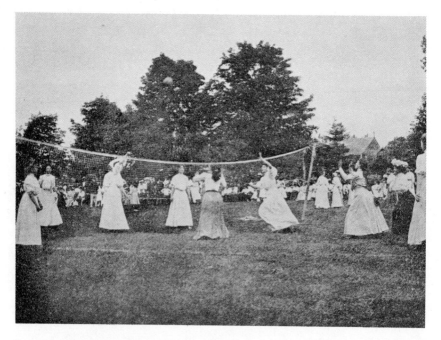

Palm Punch in the Nineties.

[Photo: G.P.A.

Boulter's Lock in 1888. Now it is quite double the
size. The Steam Launch is indicative of a past age. [Photo: Paul Martin.

At the Boat Race in 1886. A first attempt with a half-
plate Lancaster Instantograph. [Photo: Paul Martin.

Oxford embarking for the Race.　Little change here.　　[Photo: *Country Life.*

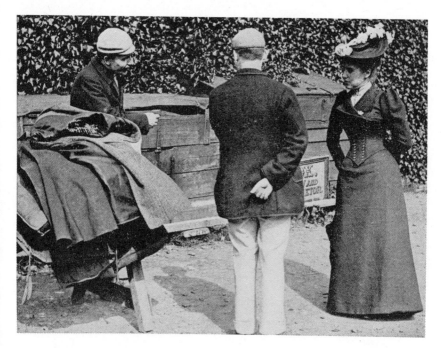

Waiting for the Boat at Richmond.　　[Photo: Paul Martin
G.P.A.

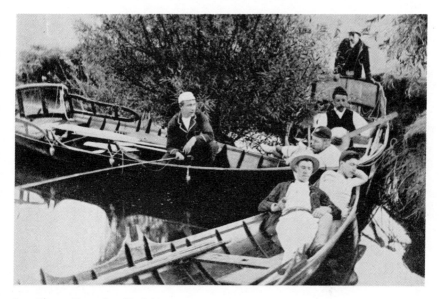

In 1887, a Camping Holiday on the Thames at Iffley Pool. [Photo: Paul Martin

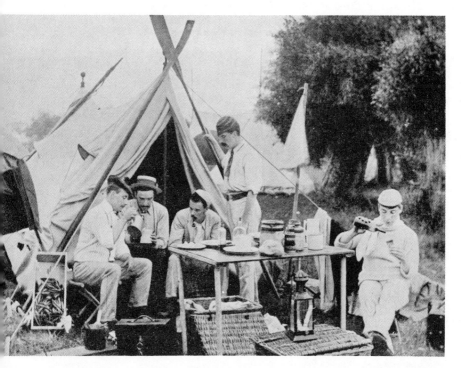

Camping Out Again in 1888. The tent shown was also used as a dark room, and although already small in size, another tent had to be erected inside to keep out any light. [Photo: Paul Martin.

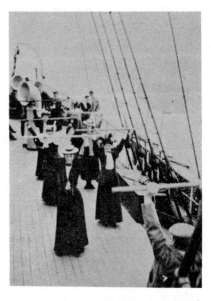

Men Only! Strenuous exercise. Note the headgear, especially the hat of the man on the right. [Photo: E.N.A.

The Keep-fit Class of fifty years ago. Morning exercises with broomsticks. An early cruising picture. [Photo: E.N.A.

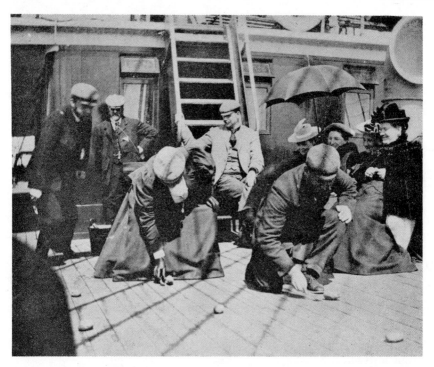

When Grandma went Cruising. The first cruise to Norway, nearly fifty years ago. A potato race in progress. [Photo: E.N.A.

Paddling Costume, about 1900.

Riding Clothes, about 1900.

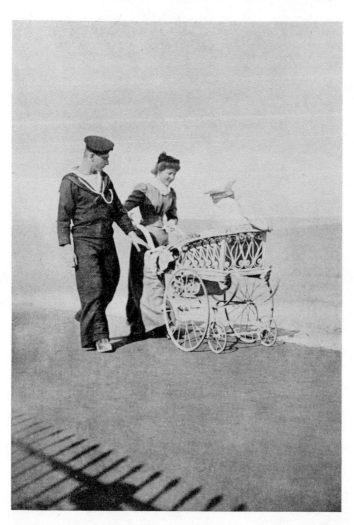

A Girl in every Port. Little changed to-day, except for
the perambulator. [Photo: *Country Life*.

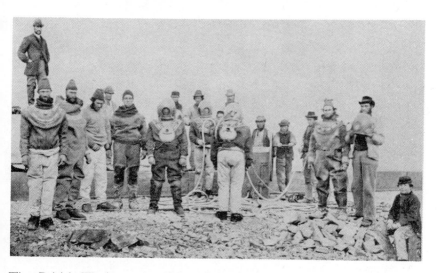

The British Workman in 1867. A group of divers at
the Landing Pier Works, Douglas, Isle of Man.

[Photo: E N.A.

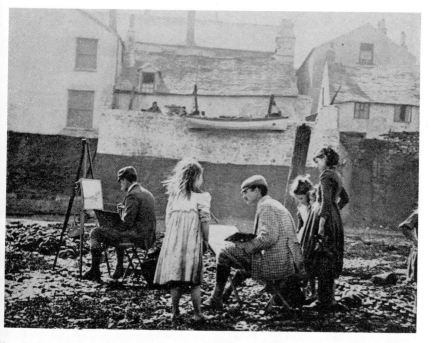

Appledore. A noted place for Artists. This was in 1894.

[Photo: Paul Martin.

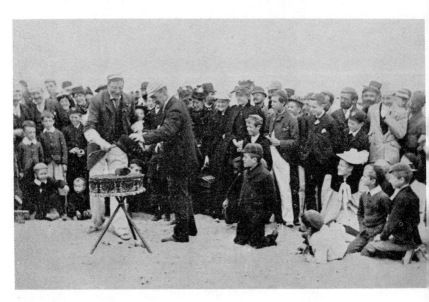

On Holiday with a " Facile " at Yarmouth in 1892.
Nobody suspected that what looked like a cornet case
was a camera in disguise. At the conjuring performance
on the sands. [Photo: Paul Martin

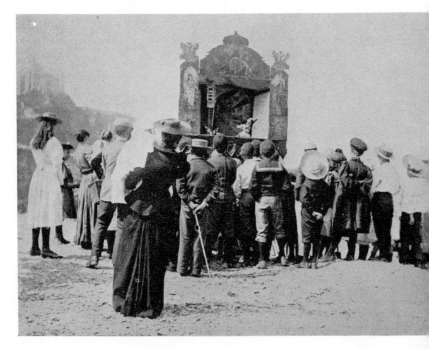

Punch and Judy Show at Ilfracombe. [Photo: Paul Martin

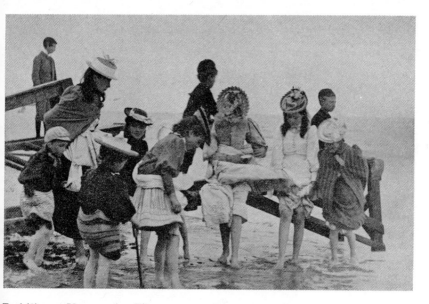

Paddling at Yarmouth. These young girls never suspected
that the eye of the camera was upon them.

[Photo: Paul Martin.

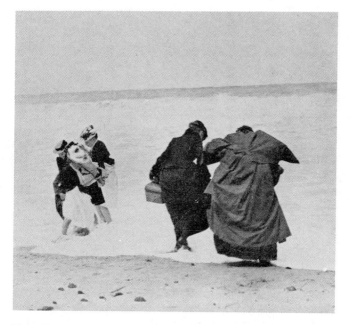

Trippers made a good target for the " Facile," as this
photo shows.

[Photo: Paul Martin.

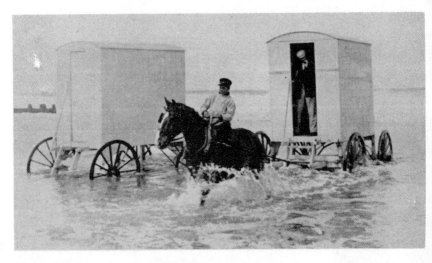

Bathing at Yarmouth was quite a Ritual. [Photo: Paul Martin.

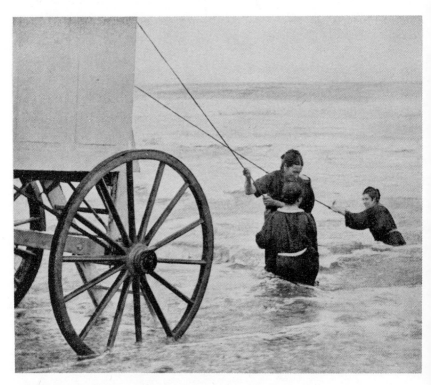

The section reserved for the ladies was at the opposite
end of the beach. The water here was quite six inches
deep, so that the fear of drowning was negligible. [Photo: Paul Martin.

56

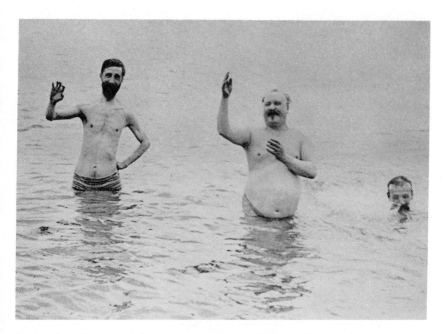

Jersey in 1893, and here are a party of three from
Birmingham.

[Photo: Paul Martin.

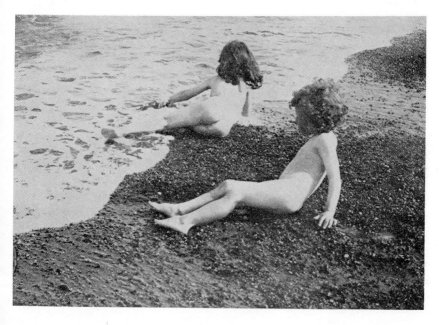

Early Sunbathers.

[Photo: *Country Life.*

57

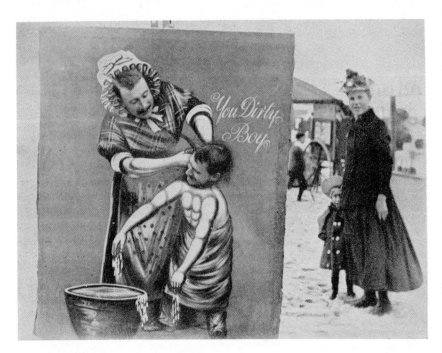

"You dirty boy!" Once again at Yarmouth. Taken with the author's "Facile" during the absence of the beach photographer.

[Photo: Paul Martin.

Bathing Dresses in the Wind.

Photo: G.P.A.

A Deal Boatman with his Children, 1888. The boatman is wearing a sealskin cap common in those days, but the girl is wearing a 1939 hat.

Taken with a Whole-plate Camera at Deal in 1888 at the Boatmen's request.

Children playing at the fishing end of the beach at
Hastings Old Town. A swing from father's boat. [Photo: Paul Martin.

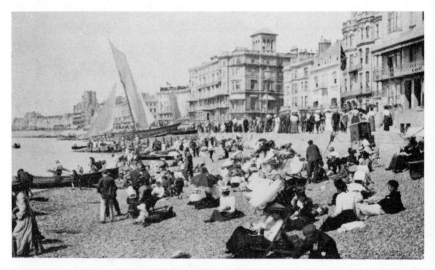

Hastings Sea Front in 1896. Now changed to covered
promenade and underground car parks. Where there was
once fishing boats there is now a coaching station. [Photo: E.N A.

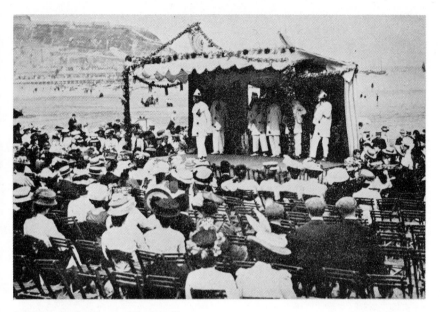

A Pierrot Show at a Seaside Resort.

Photo: *Topical Press.*

The Menagerie on Yarmouth Sands. A great attraction to the children, especially as it contains at least three monkeys.

Photo: Paul Martin.
G.P.A.

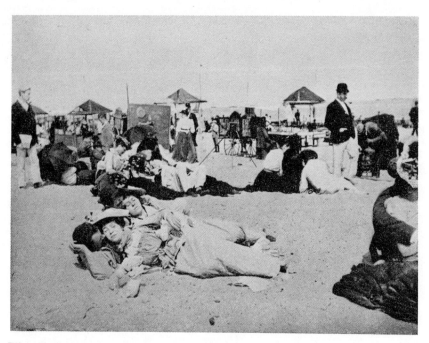

The Concert Party does not begin till 3 p.m., so there is
little to do till then, so young couples have a rest on the
sands in the friendliest way.

[Photo: Paul Martin.

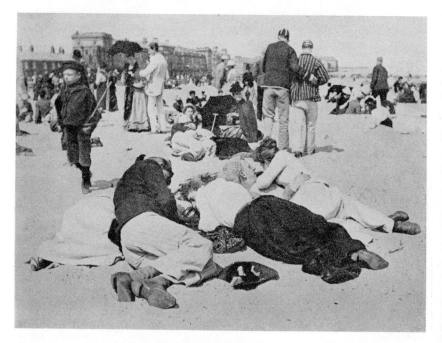

They now call these " Candid " Photographs. [Photo: Paul Martin.

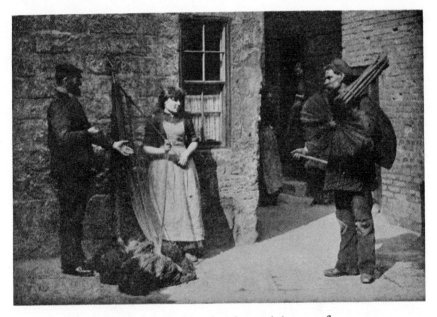

Fisherman and Sweep. A study that is reminiscent of the modern magazine illustration.
[Photo: F. M. Sutcliffe.

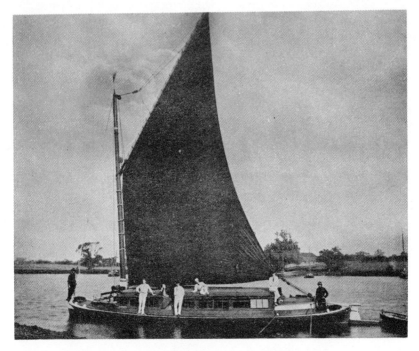

On Oulton Broads nearly fifty years ago. A Pleasure Wherry in 1890.
[Photo: E.N.A.

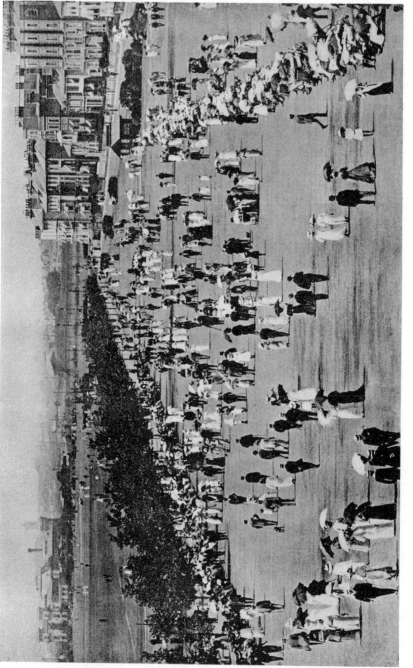

Southsea forty-three years ago. " The Ladies' Mile."

PUBLIC EVENTS AND THE PRESS

PUBLIC EVENTS AND THE PRESS

AT a very early date in the history of photography there was an impulse to record great events for posterity. In spite of technical difficulties the photographer with his clumsy apparatus got himself on the spot, until his appearance was gradually accepted and eventually welcomed by public men as a necessary tribute to their greatness. One of the earliest real snaps which we possess is of the opening of the Crystal Palace (illustrated in the Introduction). It must be remembered, however, that at first there was no means of reproducing such photographs in the Press and that therefore they could only serve as a basis for the wood-engraver to copy by hand. Right up to the end of the century the *Illustrated London News* was copying photographs in this way. Direct reproductions of photographs were confined mostly to portrait groups and scenery. The trouble was that the stand camera gave the photographer little opportunity of close-up views, and it was not till the hand camera and fast plate came to his aid that anything in modern newspaper technique was feasible.

Even in the last century the American photographer was distinguishing himself by his ubiquity and impertinence, so that chance more often brought lucky shots his way. Paul Martin himself became one of the earliest Press photographers in England, having the advantage of his wood-engraving experience, whereby he knew instinctively just what scene would make the best picture for the Press.

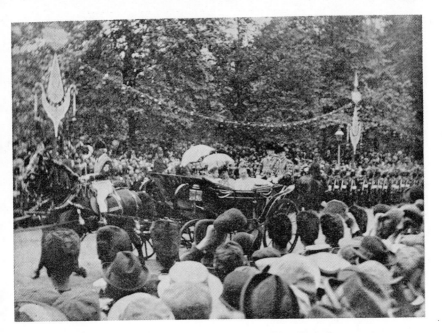

Queen Victoria's Diamond Jubilee, 1897. The Royal Princesses' Carriage passing down Piccadilly. Taken with the " Facile." [Photo· Paul Martin.

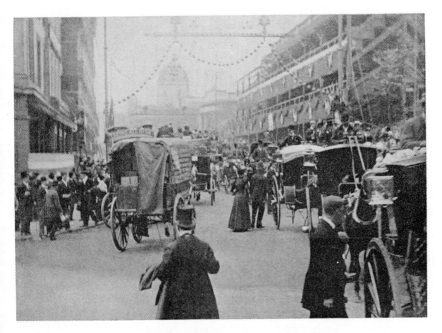

The Town was decorated for the occasion. St. Martin's Church was enveloped by a huge stand. This was repeated all along the route, on both sides of the Thames. [Photo: Paul Martin.

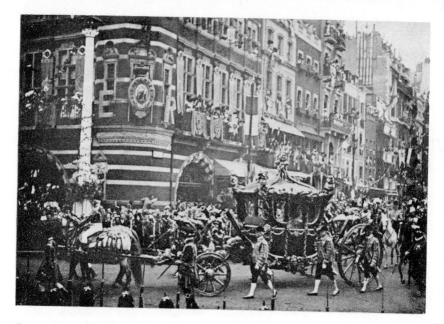

Coronation of King Edward VII, 1902. The Royal Coach
turning into St. James's Street from Pall Mall.

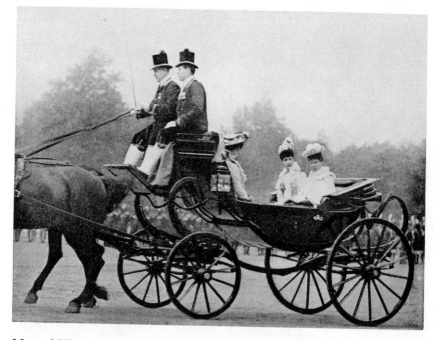

Many Military Reviews were held at the Horse Guards
Parade. Here is Queen Alexandra arriving with the
Princess of Wales (Queen Mary).

66

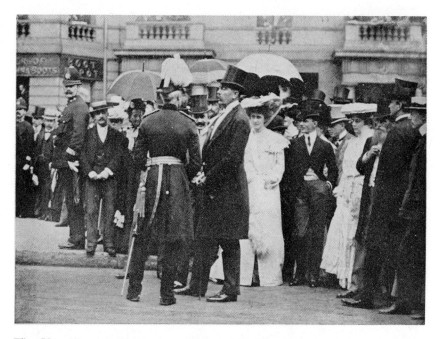

The Unveiling of the Statue to General Gordon in 1902,
eventually to be erected in Khartoum. It was unveiled
by the Duke of Cambridge. General Kitchener attended
in mufti, and is seen talking to General Trotter.

[Photo: Paul Martin.

Medals were presented to the Officers who took part in
the Boer War, and here we see groups of officers talking
together after the ceremony.

[Photo: Paul Martin.

The Launching of H.M.S. *Royal Arthur* by Queen Victoria
in 1891 at Portsmouth harbour.

An Explosion on one of the Dredgers during the making of
the Suez Canal.

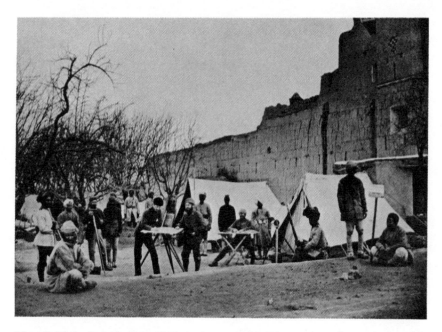

The British Occupation of Kabul in 1880. The survey and signalling headquarters.

[Photo: E.N.A.

The earliest picture from New Guinea. Commodore Erskine proclaiming the Protectorate at Port Moresby in 1884.

[Photo: E.N.A.

69

An interested spectator at one of the Military Reviews was Prince George of Greece at a window of the Horse Guards. With him is young Prince "Eddie" (Duke of Windsor), who, after some persuading, appeared in the photograph. [Photo: Paul Martin.

Taken during rehearsal at the Alhambra. An early flash-light, which filled the theatre with smoke. [Photo: Paul Martin.

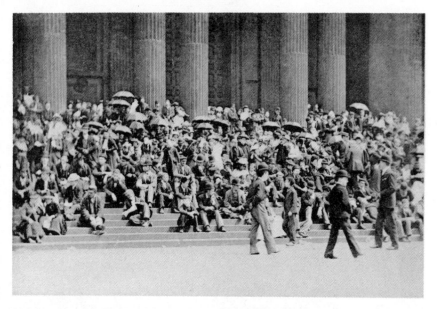

Waiting for the Duke of York and Princess May to pass
on their way to Liverpool Street for their honeymoon
after their marriage at Westminster Abbey.

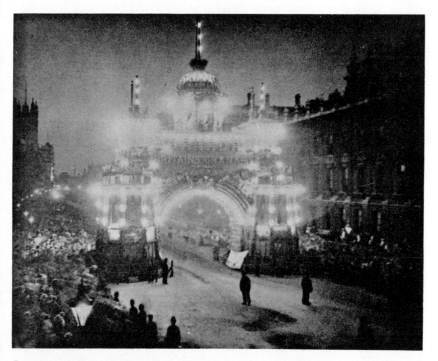

Coronation Year of King Edward VII, 1902. The Cana-
dian Arch erected in Whitehall illuminated at night by
electricity, and made the first big electric display seen
in London.

An Early Motor Sports Car. [Photo: G.P.A.

An Early Motoring Trial at Godstone. [Photo: *Country Life*.

72

THE LITERATURE OF PHOTOGRAPHY

AN ARNO PRESS COLLECTION

Anderson, A. J. **The Artistic Side of Photography in Theory and Practice.** London, 1910

Anderson, Paul L. **The Fine Art of Photography.** Philadelphia and London, 1919

Beck, Otto Walter. **Art Principles in Portrait Photography.** New York, 1907

Bingham, Robert J. **Photogenic Manipulation.** Part I, 9th edition; Part II, 5th edition. London, 1852

Bisbee, A. **The History and Practice of Daguerreotype.** Dayton, Ohio, 1853

Boord, W. Arthur, editor. **Sun Artists** (Original Series). Nos. I-VIII. London, 1891

Burbank, W. H. **Photographic Printing Methods.** 3rd edition. New York, 1891

Burgess, N. G. **The Photograph Manual.** 8th edition. New York, 1863

Coates, James. **Photographing the Invisible.** Chicago and London, 1911

The Collodion Process and the Ferrotype: Three Accounts, 1854-1872. New York, 1973

Croucher, J. H. and Gustave Le Gray. **Plain Directions for Obtaining Photographic Pictures.** Parts I, II, & III. Philadelphia, 1853

The Daguerreotype Process: Three Treatises, 1840-1849. New York, 1973

Delamotte, Philip H. **The Practice of Photography.** 2nd edition. London, 1855

Draper, John William. **Scientific Memoirs.** London, 1878

Emerson, Peter Henry. **Naturalistic Photography for Students of the Art.** 1st edition. London, 1889

*Emerson, Peter Henry. **Naturalistic Photography for Students of the Art.** 3rd edition. *Including* The Death of Naturalistic Photography, London, 1891. New York, 1899

Fenton, Roger. **Roger Fenton, Photographer of the Crimean War.** With an Essay on his Life and Work by Helmut and Alison Gernsheim. London, 1954

Fouque, Victor. **The Truth Concerning the Invention of Photography:** Nicéphore Niépce—His Life, Letters and Works. Translated by Edward Epstean from the original French edition, Paris, 1867. New York, 1935

Fraprie, Frank R. and Walter E. Woodbury. **Photographic Amusements Including Tricks and Unusual or Novel Effects Obtainable with the Camera.** 10th edition. Boston, 1931

Gillies, John Wallace. **Principles of Pictorial Photography.** New York, 1923

Gower, H. D., L. Stanley Jast, & W. W. Topley. **The Camera As Historian.** London, 1916

Guest, Antony. **Art and the Camera.** London, 1907

Harrison, W. Jerome. **A History of Photography Written As a Practical Guide and an Introduction to Its Latest Developments.** New York, 1887

Hartmann, Sadakichi (Sidney Allan). **Composition in Portraiture.** New York, 1909

Hartmann, Sadakichi (Sidney Allan). **Landscape and Figure Composition.** New York, 1910

Hepworth, T. C. **Evening Work for Amateur Photographers.** London, 1890

*Hicks, Wilson. **Words and Pictures.** New York, 1952

Hill, Levi L. and W. McCartey, Jr. **A Treatise on Daguerreotype.** Parts I, II, III, & IV. Lexington, N.Y., 1850

Humphrey, S. D. **American Hand Book of the Daguerreotype.** 5th edition. New York, 1858

Hunt, Robert. **A Manual of Photography.** 3rd edition. London, 1853

Hunt, Robert. **Researches on Light.** London, 1844

Jones, Bernard E., editor. **Cassell's Cyclopaedia of Photography.** London, 1911

Lerebours, N. P. **A Treatise on Photography.** London, 1843

Litchfield, R. B. **Tom Wedgwood, The First Photographer.** London, 1903

Maclean, Hector. **Photography for Artists.** London, 1896

Martin, Paul. **Victorian Snapshots.** London, 1939

Mortensen, William. **Monsters and Madonnas.** San Francisco, 1936

*Nonsilver Printing Processes: Four Selections, 1886-1927. New York, 1973

Ourdan, J. P. **The Art of Retouching by Burrows & Colton.** Revised by the author. 1st American edition. New York, 1880

Potonniée, Georges. **The History of the Discovery of Photography.** New York, 1936

Price, [William] Lake. **A Manual of Photographic Manipulation.** 2nd edition. London, 1868

Pritchard, H. Baden. **About Photography and Photographers.** New York, 1883

Pritchard, H. Baden. **The Photographic Studios of Europe.** London, 1882

Robinson, H[enry] P[each] and Capt. [W. de W.] Abney. **The Art and Practice of Silver Printing.** The American edition. New York, 1881

Robinson, H[enry] P[each]. **The Elements of a Pictorial Photograph.** Bradford, 1898

Robinson, H[enry] P[each]. **Letters on Landscape Photography.** New York, 1888

Robinson, H[enry] P[each]. **Picture-Making by Photography.** 5th edition. London, 1897

Robinson, H[enry] P[each]. **The Studio, and What to Do in It.** London, 1891

Rodgers, H. J. **Twenty-three Years under a Sky-light,** or Life and Experiences of a Photographer. Hartford, Conn., 1872

Roh, Franz and Jan Tschichold, editors. **Foto-auge, Oeil et Photo, Photo-eye.** 76 Photos of the Period. Stuttgart, Ger., **1929**

Ryder, James F. **Voigtländer and I:** In Pursuit of Shadow Catching. Cleveland, 1902

Society for Promoting Christian Knowledge. **The Wonders of Light and Shadow.** London, 1851

Sparling, W. **Theory and Practice of the Photographic Art.** London, 1856

Tissandier, Gaston. **A History and Handbook of Photography.** Edited by J. Thomson. 2nd edition. London, 1878

University of Pennsylvania. **Animal Locomotion. The Muybridge Work at the University of Pennsylvania.** Philadelphia, 1888

Vitray, Laura, John Mills, Jr., and Roscoe Ellard. **Pictorial Journalism.** New York and London, 1939

Vogel, Hermann. **The Chemistry of Light and Photography.** New York, 1875

Wall, A. H. **Artistic Landscape Photography.** London, [1896]

Wall, Alfred H. **A Manual of Artistic Colouring, As Applied to Photographs.** London, 1861

Werge, John. **The Evolution of Photography.** London, 1890

Wilson, Edward L. **The American Carbon Manual.** New York, 1868

Wilson, Edward L. **Wilson's Photographics.** New York, 1881